Thoughts on an Index Not Freely Given

Thoughts on an Index Not Freely Given

John Roberts

Winchester, UK
Washington, USA

First published by Zero Books, 2016
Zero Books is an imprint of John Hunt Publishing Ltd., Laurel House, Station Approach,
Alresford, Hants, SO24 9JH, UK
office1@jhpbooks.net
www.johnhuntpublishing.com
www.zero-books.net

For distributor details and how to order please visit the 'Ordering' section on our website.

ISBN: 978 1 78535 378 9
Library of Congress Control Number: 2015960680

A CIP catalogue record for this book is available from the British Library.

Design: Stuart Davies

Printed and bound by CPI Group (UK) Ltd, Croydon, CR0 4YY, UK

We operate a distinctive and ethical publishing philosophy in all
areas of our business, from our global network of authors to
production and worldwide distribution.

CONTENTS

Introduction

Oblique Referents

These chapters are imagined as being written between 1984 and 1990 at the height of the debate on modernism and postmodernism, and, as such, represent an engagement with the aporias, ideological effusions and theoretical fundamentals of that time. In this they seek various exits from, or critical amplifications of, the preoccupations of those years. Indeed, from the depths of a recent period of cultural and political reaction they propose a set of 'oblique referents' for a (virtualized) materialist art theory. Each artist here has no actual biographical existence, yet exists, in thought and imagined practice, as a prospective horizon, ideal or symptomal torsion of those times; in other words, these artists' works exist on the page as a sequence of 'conceptual practices' and, therefore, have validity and value as artworks in this textual form. Consequently, these practices function akin to 'thought experiments' in art theory. But these thought experiments are not thereby idle anachronisms, free-floating projections, Borgesian fictions, or Oulipian exercises. On the contrary, their concerns are immanent to the issues and problems of those years, and as such, they provide a range of creative interruptions and reflections internal to the antagonisms and critical issues of the 1980s. They are, in these terms, concrete negations and translations of the period, rather than elaborate reconstructions of the thinking and concerns of the time. Their historical function is *implicative*. Accordingly, their 'truth-effects' are not just the outcome of a fictive mode, for the work under analysis is the imagined response to a set of real problems, encounters and conditions.

The fact that art theory can adopt this implicative mode and voice is not all in the favour of the productiveness of art theory,

1

as if this were to demonstrate the vast creativity and unbound-edness of art writing. But it does point to a strange anomaly in art theory's encounter with the artwork, or better, the *historical scene* of the artwork, after Duchamp. The experience of art can make sense, and have a perfectly legitimate life and existence, outside of the artist's real-world authorial biography and art's extant, material forms. That is, art, or the authentic 'art-effect', can exist perfectly well not just in conceptual form – as art-idea produced by the artist – but as an *imaginary act as art-idea*. We might call this a form of 'second order' art-idea conceptualization. These 'thought experiments' consequently are second-order conceptu-alized artworks. But, in addition, we also need to recognize that the term 'second-order conceptualization' is, in its own fashion, clumsy and inappropriate. These imagined works are freely proposed as part of a critical account of the 1980s, they are not an exercise in literary or theoretical legerdemain, as if what matters above all else is the exoticism of the historical encounter with art and the artist. In this sense, we are in a different domain than simply that of the writerly conceptual artwork – although undoubtedly this writerly process plays its part. Rather, the implicative mode adopted here invites a revisitation of historical materials as a productive disordering and reinscription of their horizon and problems: a critical virtuality. Accordingly there is no *pure* fictionality here. These historical constructions are produced as an invitation to make history (and art history) live beyond chronology and the calendrical.

Chapter 1

Andrew Montalban: A Death Retold (1984)

When Andrew Montalban made his first sequence of paintings, on what he called 'absent disclosure', in 1979, he had long thought that 'abstraction' was a poor concept for anything that painting might want to do after late modernism and its retinue of formal constraints. In this respect he bristles at the idea that if painting is to recover a future for itself it has to revive a relationship with 'abstractedness', as if 'abstractedness' was what painters needed in order to reclaim their historic vitality; or at least get out of bed in the morning.[1] Abstraction, he says, encourages either the "hysteric or the depressive."[2] But, then, he also recognizes that abstraction at least cleared up an abiding problem in painting after modernism: you either fill up the space, or you don't fill up the space; you either rough up the surface or you don't rough up the surface. Either is good; there is no maximum or minimum level of expressive detail that secures 'painterly interest' or what he calls "painterly exactitude." This is why Vladimir Malevich's entropic break with all the descriptive machinery of naturalism and realism, and with the bio-forms of early twentieth-century 'half-figuration', was so overwhelmingly liberating, he declares. Painting finally got rid of all that overburdened expressive zeal and humanist claustrophobia. But there is a downside, one that the current postmodernists deny or ignore in the hope that filling things up again, in tumbling, florid, sumptuous (non-sumptuary) ways, *will* make things better or less historically burdensome: after Malevich, *filling things up and stripping things out of painting lives out a kind of wretchedness and self-disgrace.* Gerhard Richter is one of the few painters of the moment who embraces this wretchedness and self-disgrace with any alacrity; and Montalban acknowledges this as a strength in

3

the painter, quite separate from the painter's appeal to the contemporary debate on simulation and the critique of authorship. But at the same time, Montalban mistrusts the high cultural *élan* of Richter's work, its self-evident adjustment to museum and painterly spectacle. Indeed, it is hard not to see Richter as using the historical degradation of painting to mount a concerted revival of a precious, *fin de siècle* melancholia. Formally, lying somewhere between a disordering vision of 'Germania' (each painting stands as a historical death-head) and the reification of painting-as-good-design under the aegis of the Werkbund, the reflux-deluxe 'history painting' of Richter is openly operatic and Wagnerian. "Richter is the master of opulent negation; my paintings, are kind of scraggy and workaday by comparison."[3]

As such, Montalban knows he's not a classical modernist trying to redeem the fallen, heroic past, but neither does he find any appeal in the present range of postmodern displacements and catch-alls. In fact, he doesn't think painting needs 'revivifying', 'revitalizing', 'rehistoricizing' at all; painting can only replenish itself through the patient recognition and constant reassimilation and foregrounding of its own death. And this is why there is no metaphoric ambiguity on this matter for Montalban. Painting, without doubt, he insists, has died; the reality of this is unambiguous, indefatigable. Hence painting has not passed away in name – as the postmodernists believe – to be thereafter revived in spirit; it is historically and culturally overthrown. There is absolutely no mistake about this: "this is not anti-art rhetoric or a nihilistic bluff."[4] But this is precisely what makes it potentially interesting as an end-state condition, he adds; and why 'black' as the historic and philosophic colour of its death and mourning for its past is for Montalban what gives painting, paradoxically, its possible 'lightness' as an activity. For, in its insistent entropic blackness, it makes no show of anything but painting's own intractability, foreclosure and repose. In this

respect painting-*as*-blackness, in its suspended telos, is a relentless a-rhythmic recall and reinscription of painting's demise.

In *Darkened Interiors: Belize* (1980), a sequence of four black-on-black-on-black-on-black canvases (63cm x 108cm), speckled in various places with tiny, almost-invisible clusters of silver and white dots, Malevich's original black-on-black is re-haunted through Ad Reinhardt's black-on-black; that is, the overlapping of black-on-black-on-black-on-black is not a pastiche of both artists' work, but, in its a-rhythmic recall, an *asymmetrical assimilation of their negations in continuity*. This is why Montalban's painting operates as a philosophical extension of Malevich and Reinhardt's prior end-moves; a 'holding to' the claims of these negations as a reinvention of the *enlightened horizon* of the death of painting. The strategy of black-on-black, therefore, is the creative negative substance of painting's historical continuity, and not the nihilistic emptying of its history. One of his favourite quotes is from Daniel Buren's 'It Rains, It Snows, It Paints' from *Five Essays* (1973):

"Art-and-anti-art" now constitute a single unit, defining limits within which art is continually bounced back and forth. What finally happens is that the notions of art and anti-art cancel each other out, and all our cherished beliefs: art as affirmation, art as protest, art as the expression of individuality, art as interpretation, art as aestheticism (art for art's sake), art as humanism, are stripped of significance. The artist task is no longer to find a new form of art or counter art with a new anti-form; either pursuit is henceforth totally pointless.[5]

Perhaps this is not exactly the *enlightened* horizon of supersession and death, in the light of Buren's institutional practice since the early 1970s, yet there is certainly a point of congruence here.

Anti-art is not, in respect of the radical formal reduction of painting, an attack on or refusal of art at all. Rather it is liberation from what art history has willingly accepted as the class-bound space and destiny of human creativity. Montalban, therefore, acknowledges Buren's implicit rejection of this class-bound destiny, yet refuses to speak of the 'pointlessness of art' in the period of this oppressive interregnum. Such a position is simply the 'death of painting' as a torpid theme, a capitulation to enervation and bad faith. Hence there is an exacting content to repetition and re-inscription, and it lies, precisely, in the (asymmetrical) re-functioning of intention in the recovery of honoured antecedents. The work in its repetitive insistence on precedent is a renewed and re-articulated moment of challenge and expectation.

Thus we need to adjust our periodization of art in the twentieth century. Art's entropy in the early period of modernist negation is not a dissolution of art's energies, but, in a withdrawal from the routine of appearances, a betting on something beyond art itself, or, more precisely, beyond how it is presently conceived: an art that knows no distinction between form, life and praxis, and, accordingly, offers the negation of the negation as a living continuum, in which art and non-art co-exist. So, we need to recalibrate our capacity for imaginative construction in looking at Montalban's *Darkened Interiors: Belize*, and the two series he produced immediately after, *Darkened Interiors: Madrid* (1981) and *Darkened Interiors: Malaga* (1982). Black-on-black-on-black-on-black is the promise of the Absolute and not the defeated sign of 'end times'. In this respect it is easy to confuse this sequence of works with the current apocalyptic mood and ethos, where every painter of critical ambition wants to link a post-minimalist grammar in painting with metaphors of social implosion. Metaphoring enclosure and the carceral (Foucault) is not what concerns Montalban. Indeed, there is something feebly elevated and pleonastic about such moves, as if

entropy needs a sugared pill to make it palatable and modern and relevant. In contrast, what concerns Montalban is that the wretchedness and self-disgrace of painting turns the viewer of the art 'outwards' or beyond its phenomenal forms to history itself. The cognitive demands of the painting derive from what the painting presupposes beyond its inert conditions. Consequently, the value of the work does not merely lie in the way the spectator adjusts to the immanent translation of black into black into black into black, but in how the density of the black – its *historical* density – severs the art experience from the presented object. In meeting the phenomenal non-event of the blackness, cognition and thought move out beyond the edges of the painting, of the subjectivity of the artist, of the institution, into those social spaces that blackness and entropy presuppose and invite for reflection. There is a discussion to be had, then, as much on the epistemological character of blackness (and history) as on painting.

To paint in black as if to paint as black – as a kind of blackening – is to refuse certain assurances and even civilities of making art. Art is abandoned to the expulsive – nothing discrete gets back in, so to speak. Yet, of course, such expulsion cannot secure the conditions of exclusion absolutely. For if the diurnal and the ontic are refused admittance in this kind of painting, aesthetics and the aestheticized spectator are not. No painting, however bleak, self-negating, tawdry, 'empty', blank, *sans*-light is free from the transcendental aesthetic move, that is, free from the place that the work initially sets out to negate in anger and dismay: the *unearned* pleasure generated by academic art and modernist aesthetics. Which makes the move to black-on-black a profoundly disappointing experience for the painter hoping for radical cultural transformation and the emancipation of art from bourgeois aestheticism (as Malevich and Reinhardt soon found out). In anti-art and anti-aestheticism, the non-disclosure of the ontic always creates its own distinct aesthetic pleasures – hence

the self-disgrace attached to the pursuit of such forms of anti-aestheticism. The simplest and most emphatic acts of withdrawal and obduracy become, inevitably, the small change of aesthetic assimilation. But, paradoxically, this unavoidable submission to aesthetic transcendentalism in the name of anti-art is all to the good for Montalban: for, post-Malevich and post-Reinhardt, there is *nothing to lose* by an admission of the intractable aestheticism of the artwork. The historical achievements of Malevich and Reinhardt, for all their own artistic and political disappointments, were precisely of this order: namely, that they exposed the mystificatory nature of anti-art as a would-be anti-bourgeois escape from this condition. Painting cannot but produce a 'transcendental effect', even in its most abject state of wretchedness and miserliness. Therefore, the artist should treat this as the limit horizon of the painterly experience – as a given realist premise[6] of painterly wretchedness – and therefore an opportunity for reflection on what this might provide on the other side of painting and art under bourgeois culture. This means we need some additional philosophical help from Hegel's thinking on blackness and death.

The death of painting, in its blackness imagined or actual (in the case of Montalban), is what Hegel saw, in his account of historical time, as the *putting to work* of historical limits. That which is judged to be superseded is not lost to the past, nor simply assimilated through its negations, but is in fact determinate on the outcome, direction and content of the process of supersession.[7] In other words, that which has been subsumed or transcended acts on the conditions of possibility of the present and our understanding and critical uses of the past. We might argue therefore, in these terms, that the death of painting is the agency of a new beginning, but that this new beginning is not *freely* given; the new beginning is preconditioned and shaped by the continuing traction and intractabilities of the past. This is because, although dead, painting is not in fact empirically 'over'

at all (as the privileged form of the art commodity), nor can it be under commodity exchange, and, therefore, its death continues to determine art's reflection on its historical condition as a delimited life-in-death – irrespective of the expansion of recent practice beyond painting, into art 'in the expanded field'.[8] A new beginning as the same in difference, as the form of this life-in-death, is the means, therefore, by which this historical gap between transcendental aesthetic effect and hollowed out tradition is foregrounded as a continuing problem of value. But the foregrounding of this gap is not just a theoretical exercise, as if painting can now only be practiced to serve notice on its exchange value and art's market culpability: all the post-medium practices that presently have taken the place of painting are no less subject to these forces and pressures, so painting has no privileged commodity status, even if the market inflates painting's exchange value. This is why to treat painting as formally redundant – as a set of limited and repeatable formal moves to hang the critique of the commodity on – is to use repetition merely as an *oxymoronic* strategy of negation. That is, if painting is dead and paintings are hypostatic commodities, as the argument goes, then let us endlessly repeat painting's entropic condition, in the heightened spirit of this hypostasis as a commodified death. Rather, the recourse to repetition, to life-in-death *as* painting, is a way of staging what the aesthetic *promises*, beyond its capture by the commodity form and a dead tradition. In other words, the moment of transcendental aesthetic disclosure displayed in works such as Montalban's, (which palpably reject painterly aesthetics and painting's would-be aesthetic *telos*), represents the possibility of an aesthetic thinking – an aesthetics of life and praxis – beyond the tendentious elevation of certain historical forms, and not a rejection of aesthetics per se. Aesthetics, then, housed in the life-in-death tradition of black-on-black-on-black-on-black painting, is also, paradoxically, a recognition that the job of the artist is as much to

defeat this oxymoronic critique of the commodity form (critique as inert repetition), as it is to take his or her distance from bourgeois aestheticism. Both positions close down the supplementary space and encounter of the transcendental aesthetic effect as a social and collective experience.

Black-on-black-on-black-on-black, then, is the enlightened, light-giving, lightened promissory act of the artist; if this is a (dark) gift that goes on giving, however, it is gift not of form per se, but of artistic practice, deliberation and strategy. Hence we should take seriously the fact that Buren quotes Maurice Blanchot in 'It Rains, It Snows, It Paints', from *L'Espace Littéraire* (1955).[9] For Blanchot provides us in this book, and in particular in the essay 'Littérature et le droit a la mort' from *La Part du Feu* (1949),[10] with an additional set of arguments for a materialist and Hegelian defence of the negative relations of painting and the artist as forces of 'absent disclosure'. For, Blanchot's own invitation to 'blackness' (death) in art enables us to take seriously the question of why, despite painting's loss of historical justification, there is a release of energy, of life-in-death, from the foreclosure of painting. Why, under these conditions,

> does art appear for the first time to constitute a search for something essential; what counts is no longer the artist, or his feelings, or holding a mirror up to mankind, or man's labor, or any of the values on which our world is built, or those other values of which the world beyond once held a promise. Yet art is nevertheless an inquiry, precise and rigorous, that can be carried out only within a work, a work of which nothing can be said, except that it is.[11]

In these terms Blanchot is the great Hegelian theorist of deathly beginnings that, in their confirmation of life-in-death, provide a space of action, of the *deed* for painting, as opposed to the solely epistemological problems of 'representation' and 'anti-represen-

tation': the deed here being the painterly act of fidelity to painting's deathly beginning, against all odds. Under the jurisdiction of these deathly beginnings, therefore – to borrow from Blanchot's thoughts on literature from 'Littérature et le droit a la mort' – the act of painting "confirms itself as it disparages itself."[12] To make painting "becomes the exposure of this emptiness inside, to make it open up completely to its nothingness, realize its own unreality."[13] Hence, the entropic here is the very substance of the deed, not its formal constraint and inhibitor: "Looking at the wall is also turning towards the world; one is making the wall into the world."[14]

Yet, this turning of 'wall' into 'world' – as good a definition as any of the historical condition of painting in the twentieth century – has nothing to do with actionism and its expressionist modes, as if fidelity to this deed were a heroicized confrontation with self and the travails and limits of artistic subjectivity. (As such there is actually a residual 'expressionism' in Blanchot that is quite distinct from Montalban's post-expressivist concerns: for Blanchot art is of necessity compelled to expand and renews its powers of self-negation as a condition of its life-in-death vitality). Indeed, in these terms Montalban would be horrified to find that his own understanding of painting-as-deed had been recruited to the trite notion that painting was a sphere or arena for the existential artistic act, as if black-on-black-on-black-on-black represented a struggle over the painter's expressive identity. "I have no interest in what I express as a painter, but rather what painting *means*."[15] Hence, for Montalban, the deed is the *refinement of the enactment of the death of painting as a deathly beginning,* and not an expressive *invocation* of painting as black-on-black-on-black-on-black. Nevertheless, Blanchot's own embrace of the wretchedness and self-disgrace of art, as the life-in-death of art, points to a communality of spirit that touches significantly on the historical condition of painting, as a life-in-death that endures:

[W]e have questioned this absence by which the thing is annihilated, destroyed in order to become being and idea. It is that life which supports death and maintains itself in it – death, the amazing power of the negative, or freedom, through whose work existence is detached from itself and made significant.[16]

In these terms, we need a clearer understanding of the painterly act (deed) today, and its embodiment in Montalban's paintings, and, as such, what we mean by painting's 'post-expressive condition' as an enlightened and emancipatory horizon.

Painting is more than its formal debt to representation (figuration) and anti-representation; this is why abstraction is redundant as a concept and so distracting, as if freeing painting from representation constituted a qualitatively new expressive act, and a new stage of artistic liberation. The faith in abstraction in the 1950s as a new dawn is mortifying in this respect, a Dionysian veiling of the death of painting: a confusion of painting's entropic condition *with* abstraction. In other words, painting's deathly beginnings after the death of painting *is* the act of painting, insofar as painting-as-deed is the act of maintaining painting as the site of aesthetic transcendence without faith in painting as painting. Or rather, more concretely, it is the entropic condition of painting that itself determines the act of painting. This is what I mean by the entropic being the very substance of the deed; entropy is constitutive *of* the act, not its supplementary content. This is why Blanchot is a useful guide despite his own expressivist tendencies: whatever mode art adopts as a painful transformation of 'wall' into 'world', in the epoch of art's class interregnum, "it comes from night and will return to night."[17] As such, there are no escape clauses for art from art's confirmation/disconfirmation, whatever mode and forms it adopts under present conditions: black will return to black. But, nevertheless, painting has a peculiar relation to this 'return' to

blackness and to art's dialectic. Hence, the significance of Montalban's rejection of the life-in-death in painting as a process of aesthetic renewal: in the epoch of its real death and life-in-death and deathly beginnings, painting, as the deed of its own entropy, is not to be confused with the struggle *for* art's self-renewal, even if art's 'renewal' is the necessary outcome of the act. On the contrary, the *deed of painting is precisely the recovery of its act in death.* This is why we need a theory of the (painterly) act that is sensitive to the inertial drag of experience, rather than a theory of painting that links negation to the modalities of (free) expressive authorship.

Such a theory is, I would suggest, available in Emmanuel Levinas's post-war (post-Heideggerian) critique of existentialism and the existential act, in *De L'Existence à L'Existant* (1947), a huge influence on Blanchot, although we need to be careful about not rerouting the concept of painting-as-deed too comfortably into this debate; if painting (after the end of painting) needs philosophy, it doesn't need philosophical *ratification.*[18] In *Existence and Existents,* the early (and more compelling) Levinas seeks to de-heroicize the act, not in order to produce a deflationary nihilism equal to ethical life after the death camps, nor a puny or pragmatic actionism suitable for chastened post-war rebuilding, but a theory of the act – in Hegel's sense – that is purposeful under, and in alignment with, the retroactive pull of the past on the present. In order to do this he develops a concept of being that rejects the classical notion that it is through man's inviolable struggle with matter – via the virtuousness of the act of labour itself – that he is able to relieve himself of the burden of self-identity (the ego), and enact a joyous state of accomplishment and (temporary) repose. On the contrary, such a transformative encounter with matter – for all its powers of self-transcendence – fails to recognize how the act always *falls behind* the instant of its execution, that is, there is always a moment of 'weariness' between the act and its sense of

accomplishment, as if the act was repeatedly unable to suppress the subject's refusal of existence, as if being continually speaks through the act of labour. Yet this weariness, for Levinas, is not the "pain of being"[19] nor is it a kind of existential lassitude, nor an expression of indolence or indecisiveness in the face of the intractability of reality. Rather, it is what happens to the subject *in* the process of his or her exertions in the world, and, therefore, immanent *to* labour. This is why Levinas defines weariness, more precisely, as a kind of fatigue; for fatigue, unlike indolence or lassitude, is the outcome of effortful labour:

> [T]here is fatigue only in effort and labor... [H]uman labor and effort presuppose a commitment in which they are already involved. We are yoked to our task, delivered over to it. In the humility of the man who toils bent over his work there is surrender, forsakenness. Despite all its freedom effort reveals a condemnation; it is fatigue and suffering. Fatigue does not arise in it as an accompanying phenomenon, but effort as it were lunges forward out of fatigue and falls back upon it. Effort lurches out of fatigue and falls back into fatigue. What we call the tension of effort is made up of this duality of upsurge and fatigue.[20]

In this sense, for Levinas, labour and (artistic) creativity must in each instant of effort triumph over the fatigue produced by the gap between act and accomplishment. This is why effort is not an automatic fulfilment of our intentions, self-conceived or otherwise, but the faltering link between action and being.

> In the instant of a beginning, there is already something to lose, for something is already possessed, if only the instant itself. A beginning is, but in addition, it possesses itself in a movement back upon itself. The movement of an action turns to its point of departure at the same time that it proceeds

towards its goal, and thus possesses itself while it is. We are like on a trip where one always has to look after one's baggage, baggage left behind or baggage one is waiting for. An act is not a pure activity; its being is doubled up with a having which both is possessed and possesses. The beginning of an act is already a belongingness and a concern for what it belongs to and for what belongs to it.

Fatigue, then, is a kind of tautness, a hanging on, a retaining of the will in the face of the "aversion to effort", and not the subject's resistance to existence per se. The act, consequently, is not a stuttering exactly, not even strictly a suspension between doing and being, but a kind of *active halting*, in which desire and drive fold back on themselves in a continuous movement forward that, in turn, flows backward under the 'law of return'. This makes the 'act' the incursion of a subject "no longer in step with itself" given that investment in the present is not coeval with the present: in other words, the act is the lag of an existent tarrying behind its 'existing', as Levinas puts it. But if this clearly questions post-war existential doggerel about seizing the moment, labourist homilies about joy through labour – even the Nazis' barbarously ironic axiom 'work makes freedom' – and the notion of the present as a staging post for infinite progress, this active halting is not nihilist withdrawal from present as the site of struggle, as if active halting was the name for the subject's non-transformative desertion from the present. On the contrary, the recognition of a lag between doing and being seeks rather to quieten the actionist dazzle and presumption of the pure and positivized present, which is enshrined in a range of political and philosophical positions within the economy of being (Heideggerianism, Bergson's theory of pure duration and Stalinist workerism):

there is a gravity in the heart of the present, despite its break

with the past. The fatality which bears down upon the present does not weigh it down like heredity, and is not imposed on it because it was born without having chosen its birth. The present is pure beginning. But in its initiating contact, an instantaneous maturity invades it; it puts its pin in itself and is caught in its own game. It weights itself... The freedom of the present finds a limit in the responsibility for which it is the condition. This is the most profound paradox in the concept of freedom: its synthetic bond with its own negation. A free being alone is responsible, that is already not free. A free being alone is responsible, that is, already not free. A being capable of beginning in the present is alone encumbered with itself.[21]

The Hegelian de-positivization of the present here, then, identifies fatigue as a preeminently *historical* category, or as a prelude to historicity. The lag between doing and being marks a gap, between the present and the present-as-future, out of which the *unknown* present as the unknown future is produced. This is because the assumed clarity of the present, arrived at through the immediacy of the act, is quite separate from the act's understanding in historical time. If "[e]ffort is an effort of the present that lags behind the present,"[22] then the time of comprehension of the present is not the time of historical consciousness. Hence, the lag between doing and being – the gap between act and accomplishment – is the space out of which both the dis-identification of the present from the future and the non-identitary logic of historical understanding are produced. For, if act and accomplishment were one, if existence and existents were indistinguishable, history would indeed be no more than an affirmative passage from present to present – a transparent unfolding of instants – and, therefore, a process in which the agency of the historical subject is made unintelligible, in as much as the subject becomes self-identical *with* the historical process. This is why the lag between doing and being, as the ontological space of the

subject's halting withdrawal from the world, is the space where this assumed self-identity breaks down, and, therefore, the place where reflection begins its life. The lag between doing and being of the 'weary present' is also the 'conflictual' present.

Levinas's theorization of the non-identical place of the act in the economy of being has significant ramifications for how we think about the dialectic of art, as a process of confirmation/ disconfirmation. For contrary to the growing preoccupation in the rise of postmodernism with the deathly and completed exhaustion of 'grand narratives' and images of futurity[23] – which are implicitly an affirmative call to order – Levinas's opening out of the act, in its acceptance of fatigue as the *deathly* beginning of the new, avoids both the apocalyptic death of the past, and the apocalyptic call of the absolutely new, before the genuinely new can be born. Now Levinas's 'act' does not explain the deathly beginnings of Montalban's paintings, nor define their own particular active halting, as an anti-postmodernist intrusion into the growing retreat from history. The paintings do not have a special dispensation in this regard. They are not made *out of* Levinas's 'act.' Rather, they provide, like Levinas, a space in which the deathly beginnings of the act can obtain a certain cognitive and political traction. These are paintings, in other words, in which the fatigue immanent to the act is what drives the content of the art itself. That is, painting-as-deed, as the bringing forth of painting as a deathly beginning – in its explicit resistance to representation and expressiveness – is enacted as a form of historically determinate ending. This is why Montalban's black-on-black-on-black-on-black is not simply a *post*-historic *fait accompli* in Reinhardt's sense; it is not a utopian projection. Montalban's presentation of painting as an active halting makes, rather, a claim on the historic *limits and possibilities* of art. Hence, unlike Reinhardt's use of black-on-black, Montalban's black-on-black-on-black-on-black is the *making historical of endings*.

In this respect Montalban's black-on-black-on-black-on-black

is perhaps closer to an artistic appropriation of the apophatic: that is, the notion that we begin by defining art in relation to what it is not, in order to sustain its open horizon. In this sense, the deathly beginning of the margin of difference in Montalban's asymmetrical recovery of Malevich and Reinhardt's black-on-black is consequently terribly important. Montalban's *Interior* series may share a family resemblance with Malevich and Reinhardt, but his mode of production and use of paint is very different. Whereas Malevich worked small and domestically, icon-scale, as if he was producing a private token – indeed, as if he was engaged in a secretive act – and Reinhardt worked large-scale (lying the painting flat and using paint which was as reflective as possible, in order to incorporate the ontic indirectly into the work), Montalban's use of black is insistently dense, repetitive and desubjectivized (four coats of matt black applied uniformly and methodically with a roller one after another), as a way of resisting the spiritualizing and contemplative logic that played such a large part in both Malevich's and Reinhardt's art. This desubjectivization is hard to pull off, particularly when Montalban insists that the spectator needs to take time in front of the work in order to allow its absences to speak 'contrawise' historically – obliquely, that is. Of course there are no spectator guarantees here, no guaranteed parameters for how the painting is experienced and thought about. Nevertheless, it should be recognized that Montalban's paintings provide, in these terms, a 'nonpainterly' continuation of Malevich and Reinhardt's painterly entropy (remember both Malevich and Reinhardt invested a large amount of painterly finesse and artistic self-regard into their works),[24] in order to resist abstraction's contemplative spiritual warrant, and, therefore, Montalban's paintings offer minimal painterly rewards as compared to Malevich and Reinhardt. Consequently, Montalban's use of black-on-black-on-black-on-black is achieved as the result *of* the fatigue or active halting of painting's deathly beginnings. The blackness seeks an

explicit materialist identification between painting and transcen-
dental aesthetic effect. This is why expression, Montalban insists,
is the "terrible secret" of abstraction's false continuation for
painting.

> Pollock knows the terrible secret of painting, but he bullied
> the whole of experience into his pictures, as if couldn't bear to
> let painting die in front of his eyes. Twombly knows the
> terrible secret of painting, but he wants to perfume it; swoon
> in front of it. Kline I'm not sure about, he was a plodder really,
> but this is why I like Kline's work more, even if they are not
> better paintings than Pollock's and Twombly's: they are
> gawky, awkward, pathetic, moronic even. The first thing you
> think of – certainly as a painter – is why on earth didn't he
> make them better? What was his problem? But that's precisely
> what I like about them, they completely expose the absolute
> dismalness of the problem of 'expression' in abstract painting,
> whereas Twombly and Pollock cover it up and act out, and
> Newman completely represses it, as if abstraction was his
> meal ticket to become a modernist court painter: abstraction
> in a bow-tie. But if my paintings are wretched or invite
> wretchedness, they are not astringent in that Debordian,
> Situationist-type way. Debord's astringency is like having
> capitalism rubbed directly into your eyeballs, which is not
> helpful. Debord was a classic self-harmer in that respect.
> That's not what I want from art. My version of negation does
> not scour vision in that sense. My paintings may refuse, deny,
> may be intolerable, but whatever abstract ideas they embody,
> they also stir you, enchant you, relieve you of the glut of the
> world.[25]

But, if this clears up Montalban's relations with abstraction,
expression and negation in art, it presents a residual problem in
all work of this nature: the invitation to see such paintings as a

kind of conceptual heightening of either Marx's call to remove "the muck of ages"[26], or Hegel's invocation of history as the 'night of the world'. Blackness becomes converted into the currency of an anti- symbolic ecology, an iconoclastic cleansing of the senses, of the messy particularities of commodity exchange, of the everyday and the ontic. Maybe this is not astringency precisely, but it certainly presents negation as a kind of clearing, and therefore represents the invidious danger of the Heideggerian philosophical legacy that Montalban rejects: black-on-black-on-black-on-black becomes a metaphysics of a new beginning after the visitation of death (the fantasy of the new as absolute break; the 'new dawn') rather than the *determinate negation* immanent to deathly beginnings that prepares us for the genuinely new. Montalban's painting could be said therefore to prepare an exit, in order to fall prey to another exit: from historicity into historicism. And, consequently, perhaps this is the fate of all painting in the manner of Malevich and Reinhardt, historic or post-historic: that, in the end, the clearing away of the ontic in painting becomes a wishing away of the possibility of the symbolic as such.

Notes

1 Unpublished interview with the author, October 14th, 1983. See also, Andrew Montalban, 'Notes on the Critique of Abstraction', *Crowbar*, 2, (1979): pp.6–8: "Abstraction is not the subjective ground of painterly extension; it is the actual social substance of painterly death", p.7.

2 Ibid., p.6.

3 Montalban, unpublished interview.

4 Ibid.

5 Daniel Buren. "It Rains, It Snows, It Paints' in Daniel Buren, *Five Texts* (New York and London: John Weber Gallery and Jack Wendler Gallery, 1973): p.24.

6 This is the opposite though of a revived Kantian disinterest-
edness out of the realist constraints of making and talking
about paintings after Modernism. For a problematic realist
defense of such disinterestedness, see Charles Harrison and
Fred Orton, eds., *Modernism, Criticism, Realism: Alternative
Contexts for Art* (London: Harper & Row, 1984). "Ironically,
perhaps, the Modernist claims for disinterestedness of
intuition and of aesthetic judgement is worth considering at
least for its corrective value, so long as it is itself open to
causal explanation. We may have need of it so long as people
go on reading into works of art the morals and meanings
they are anxious to find in themselves or in the world"
('Introduction: Modernism, Explanation and Knowledge',
p.xxv). This is an abdication of the partisan enunciation of
painting's anti-art encounter with its own death.

7 G.F.W. Hegel, *Logic*, trans. William Wallace, foreword
J.N.Findlay (Oxford: Oxford University Press, 1975).

8 Rosalind Krauss, 'Sculpture in the Expanded Field', *October*,
No. 8, (1979).

9 Maurice Blanchot, *L'Espace Littéraire*, Gallimard, Paris, 1955.
Trans. as *The Space of Literature*, by, and with an introduction
by, Ann Smock (Lincoln: University of Nebraska, 1982).

10 Maurice Blanchot, *La Part du Feu* (Paris: Gallimard, 1949).

11 Maurice Blanchot, *L'Espace Littéraire* (p.295), quoted in
Buren, 'It Rains, It Snows, It Paints': p.24.

12 Maurice Blanchot, 'Literature and the Right to Death', in *The
Gaze of Orpheus, and other literary essays*, preface by Geoffrey
Hartman, trans. Lydia Davis, ed., with an afterword, by P.
Adams Sitney (Barrytown, New York: Station Hill Press,
1981): p.22.

13 Blanchot, ibid., p.24.

14 Ibid., p.30.

15 Montalban, 'Notes on the Critique of Abstraction', p.7.

16 Blanchot, 'Literature and the Right to Death', p.61.

17 Ibid., p.49.

18 Emmanuel Levinas, *De L'Existence à L'Existant*, (Paris: Librairie Philosophique J. Vrin, 1947). *Existence and Existents*, trans. Alphonso Lingis, Dordrecht, Boston & London: Kluwer Academic Publishers, 1978). Blanchot first met Levinas when he was eighteen and Levinas was twenty in the mid-1920s and they remained friends for life; as a French officer Levinas was interned in a prisoner-of-war camp for most of the war, and, as such, escaped deportation to a death camp; Blanchot escaped a Nazi firing squad in 1944.

19 Emmanuel Levinas, *Existence and Existent*, p.13.

20 Ibid, p.16–17.

21 Ibid, p.47.

22 Ibid, p.17.

23 Jean-François Lyotard, *La Conditione Postmoderne: rapport sur le savoir* (Paris: Les Editions de Minuit, 1979).

24 In Reinhardt's *Abstract Painting* (1963), for example, a large square divided into nine equal black squares, the corner squares have a red tint, the three horizontal middle squares have a green tint, and the remaining two squares have a blue tint.

25 Unpublished interview.

26 Karl Marx and Frederick Engels, 'The German Ideology', *Collected Works*, Vol, 5, 1845–47, (London: Lawrence & Wishart, 1976): p.53.

Chapter 2

Celestine Valence: In Spite of Herself (1985)

Celestine Valence has stated she hates myths of origin; there was no point, she says, where she claimed her status as an artist for herself or thought herself worthy of the name 'Artist'.[1] Being an artist crept up on her slowly, clandestinely, imperturbably; there was no visitation from an imagined future, laid out by teacher or friend, no kind words of another reflecting on the promise of halting efforts, no stern encouragement about 'wasted talents'. She drew, and then stopped drawing and then started again, not really knowing why she wanted to draw, and then went to the Academy in Basel, because she thought it would be fun. Everything from then on was a hesitant filling out and slow absorption. However, she does recall the time as a twelve year old, lying on her back in the high fields in the summer, near her village in the canton of Jura, Switzerland, legs and arms outstretched thinking that she could through sheer will pull everything to her in act of vast and imaginative interiorization, as if she had the power to suck in everything she could see, hear and smell around her. The captivation of that afternoon, with all its synaesthetic intensity, now seems to her as if it were an unannounced invitation to another life. Although she has never thought of that afternoon as if it were a moment when thinking and feeling connected to a process of creativity outside of her own self, nevertheless that hour in the sunshine allowed her to have a different kind of relationship to the things she looked at, and walked by, and took for granted, on a daily basis: the grazing animals, the steep fields, the high skies. Thus, it wasn't as if from that moment on she didn't love these things she knew so well – even a farm girl, with growing feelings of provincial melancholy – but that for a while these things took on an unfamiliar distance.

She felt she could be in the world, in a different way, not bound to or guided by all the demands of the ordinary stuff she touched, held and moved through on a daily basis.[2] So, if she is now not prepared to reify this memory as a source of artistic identity and autobiographical dramaturgy, she nonetheless does not want to undervalue it either, render it decorous or slightly exotic. For all its innocence it has a tangible relation to her slow and 'unknowing' formation as an artist. Hence in the magazine *Feuer Spiel*, she tells the story of this afternoon not in order to give some added autobiographical shape to her current concern in her work with extensity and immersion, but, rather, to render the moment *true* to herself and to her art. This is very different from giving it a teleological weight and significance; the past may inhabit the present, but does not explain it.

The new generation of women artists are *beset* by subjectivity, so to speak, as if the burden of subjectivity has been handed on to them, as if this generation of women-coming-to-collective-speech has been given the powers of speech for all, as if men needed such voices to know how they should feel, how they should act. Indeed this has been the basis of the vitality of second-wave feminism: if women have embraced the authority of their own speech, this speech has taken form inside the 'speechless' subjectivity of men, as if men suddenly were shown to have speech, plentiful speech, but a speech that was importune and empty, divorced from self-reflection, and therefore a speech that, for all its social authority, weakened what might count as subjectivity. The massive coming-to-collective-speech of women in contemporary art and culture since the mid-1970s, conse-quently, is not just making visible the powers of women's self-representation – women have certainly fought for the integrity of this demand – but, rather, it is the making of speech as an active disclosure of the conditions of subjectivity as such. In other words, what women bring to speech, from a place anterior and subordinate to 'patriarchal' speech, is the *making of speech as the*

making of subjectivity. And this is why this making of speech as
the making of subjectivity places women's subjectivity in a
double-articulated position: women's speech, in its refusal of
sexual subordination, is not the voice of an untrammelled
authentic subjectivity, yet, in its rejection of the authority of male
speech as the speech of transcendental reason, it bends the
speech of men back on itself and, therefore, at an important level
de-authenticates men's gendered investment in 'natural
language': forcing naturalized and unconscious language to
open itself up to the truth of sexual division. The coming-to-
speech of women artists and writers, collectively, accordingly,
has opened up an abyss between the speech of everyday
compliance (of 'men' and 'women'), and the de-reifying
demands of women's speech. Yet these demands are not simply
cognate with 'emotional transparency' or the 'confessional', as if
women's speech opposes feminine openness to masculine
closure (as if women's speech de-authenticates what is purely
'man-made' and therefore men are, by psychosocial definition,
excluded, or self-exclude themselves, from such forms of
authentic disclosure). This radical feminist fetishization of male
speech as an enforced patriarchal imposture de-socializes the
gendered production of language as multi-accentuated[3],
relativizing reason across the sexual divide and turning women
into the custodians of 'feeling'.[4] As such, this turns the neutral
transcendental reason of male speech into a speech external to
the depredations of class and to the internal fissures of
masculinity itself. In this sense men – and male writers and
artists in particular – do not need lessons in emotional *disclosure*,
as if expressiveness and the declamation of masculine interiority
were foreign to the speech of men across classes and sexuality.
The externalization of interiority is not the problem; the external-
ization of interiority as authorial and institutional power is.

Women-coming-to-collective-speech, therefore, is not defined
by the experiential shaming of 'male speech' as such, for the

making of speech as the making of subjectivity is by definition an intersubjective process; a 'bringing to account' within the realities of sexual division. Yet, if this increased sensitivity to language, subjectivity and power detaches women's speech from mere 'emoting' as a record of oppression, nevertheless second-wave feminism in art has sought to capture, and refigure, from the depths of ignominy and condescension, all kinds of experiential language as the informal speech of politics. Thus it is one thing to detach women's coming-to-speech from 'feeling'; it is another to downplay the making of speech as a means of showing and telling, of enactment and self-exposure, in order to bring women's daily experience and struggles into the symbolic, *without deferment*. And this social-psychic externalization is unprecedented. Everywhere in art by women we see female bodies and hear female voices; bodies with voices, voices without bodies; everywhere a pouring-out of speech and language; text and sound; everywhere the dramatization of self and other and the declamatory voice, the stilled voice, voices of report, incantatory voices, plaintive voices. Voices cry, scream, reflect, whisper, command, invite, deter, refuse, defy, declaim, implore, in a meeting between discretely assertive language and the deflated or captured female speech from the pages of the fictive stereotype or the symbolic margins of Hollywood films. Valence's art is part of this counter-symbolic upsurge, connecting her own coming-to-speech to the feminine landscapes of her own rural past, and her own Germanic ancestry.

Since 1980 Valence has been producing a series of 'night' installations, made from rows of hanging painted gossamer-thin sheets of black cotton, which are housed in a semi-lit environment that allows enough crepuscular light for the spectator to move through without hindrance. These 'moonlit' interiors are accompanied by a recorded woman's voice or voices, sometimes in German, sometimes in English, sometimes a mixture of both. In her 1983 installation *In Adelheim Forest* (1983),

which is vast in its complex hanging of the painted veils (allowing spectators to cross each other's path), a young female voice (the voice of an English actress) intones:

> I went on a walk... the crows crowed high in the trees... it got too dark to see... I walked on... I knew I should return... I walked on... I stumbled... I had no idea where I was going... I carried on... The moon was invisible... I took small delicate steps... I walked on... the crows crowed high in the trees... I carried on... I could see a house... I should return... the house had a light on... I should return... the house got closer... I walked on... the light got brighter... I should return... I quickened my step.

Similarly, in *In The Forest of Landau* (1983) and in *A Walk in Dessau Forest* (1984), the voice of a women whispers about not being able to find her way, it being too dark and thick with undergrowth; she knows she shouldn't have come this far, but she wouldn't find her way back; it is better to continue. In *A Walk in Dessau Forest* the woman hears the night animals; perhaps a fox, perhaps a wild boar moves in the undergrowth; there is no path, or just the trampled edges of bracken that a hunter, or a *natur-Wanderer*, has stepped on, bedding it down into the soft earth of the forest floor; the trees bristle and sway. "It's getting very cold," she says, in the active first person, "I can't stay here."

Is there a women's 'black femininity' or 'black female sensibility' in art? It's hard to point to one; and as such, in no satisfactory or obvious sense do Valence's installations claim to possess such a sensibility. Yet Valence is an artist of the 'night'– of words that spill forth from darkness. But her night is not voodoo or a version of Gothic gloom, in which the living inhabit a living, if imaginary, nether world, it is, rather, the language of neotony, of birthing from, or the passage through, darkness. And in this respect, she clearly draws on the stories collected by the

Brothers Grimm, as the great corpus of feminine neotonic trails, of the stealing of female youth and beauty by the old and aging; of youth being forced to cover up decline and stasis; of 'newness' as the reverse or retardation of development.[5] Indeed, perhaps, more starkly and directly than the Grimms themselves, Valence's darkness is the very substance of this neotony; each of her darkened environments and broken narratives is a neotonic passage into a world full of the threat of possession and dispossession. The use of darkness, of blackness, is a moot point, then for Valence. Valence's forests are not simply fairy-tale spaces, mythic spaces inhabited by waifs and damsels, but historically conceived and grounded spaces that embody the faltering steps of female historicity, or more precisely, enact, in a kind of stuttering encounter with nature, the absence of women from an active historicity. Neotony, then, is presented here as the arrested condition of both men and women (nothing truly dies or develops, instead a perpetual youth – a reified and anti-historical femininity – stands over history and the living relations between men and women). Thus, looming behind Valence's forests are many other forests and darkened woods, specifically German, French and Polish. For to place her young women in the 'way of danger' in her forests is, almost by definition, to place her women in the way of the crossroads of Germanic metaphysics, politics and nationalism. The forests of the early Romantics, of late nineteenth-century Germany Awake, of the Nazis and Heidegger, establish a deep loam of cultural precedents and associations for German speakers. Indeed, the forest emerges as the sublime antipode to a despiritualized modernity, the great brooding heart of the counter-Enlightenment imaginary, with Heidegger's Black Forest *Hütte* (near Todtnauberg) as its implacable shrine; the place where the national spirit is 'housed' and where people visit its dark interior to renew the bond with Germanic destiny. To step into the forest as a German speaker, therefore, is to step into a space with a determinate history, which has lost its direct and

expressive links between interior life and the forest's interior; the forest as the mythic testing ground of the moral life (as in Dante's Dark Wood, with all its labyrinthine challenges) to be replaced by the forest as a space of bitter nationalist enclosure and metaphysical imposture. It's difficult, then, not to read the Grimms' forests through this history; where their forests once brought a richly heightened confrontation between nature and human interiority, it now carries with it the claustrophobia of a degraded sublimity; a space of round-ups, executions and burial grounds; of the erased sounds and signs of a brutal exteriority. The forest, in myth and actuality, has, of course, always been the actual site of violence hidden from view – the inaccessible and untouchable grave of the disappeared; the haunted domain of criminal iniquity – but now, stripped of its early Romantic intimacies, its secret violence is open to view, as if the bodies have risen as one from the soft earth, as if decayed bodies and the fallen induviae of the forest floor were one. But this forest of the mass executioner also hides another secret: the deeply buried retreat and partisan enclave; the place of enduring defiance, as in Primo Levi's account of wooded Jewish partisans in Nazi-occupied Ukraine, in *If Not Now, When?*.[6] Here the forest hides a community of indefatigable souls and warriors, for whom the forest functions as the vestigial place of a nascent egalitarian community outside of the City walls. Perhaps the historical beat of this forest is weaker than the executioner's, a mere ripple, but nevertheless, this forest becomes a redoubt of history in the making. Neotony and its mythos, therefore, have a particular resonance in this setting: the dead time of permanent youthfulness is unable to freely possess its surroundings; men and women, masculinity and femininity blur.

This separation of neotony from femininity – of the staking-out of a femininity divorced from the living deathliness of neotony – is an explicit concern of Valence's latest installation, which dramatically inverts the forest as a realm of darkness. In

The Forest of Ménilmontant (1984) she stages a forest scene swept by extreme levels of light. A large Krieg lamp, installed high up on a wall, pours down its powerful beam onto a bench, behind which is placed a collection of life-size pine trees and bushes made of papier maché, all realistically painted with added natural details, such as beautifully fabricated tufts of grass, weeds and flowers, and even plastic insects. The sylvan setting encourages you to sit down, in order to view the Latin words and a line written in English on the red-painted veil hanging in front of the scene taken from Jean-Jacques Rousseau's *Reveries of the Solitary Walker* (1782)[7]: "Picris hieracioides"; "Bupleurum falcatum"; "Cerastium aquaticum"; "when I reach places where there is no trace of men I breathe freely, as if I were in a refuge where their hate could no longer pursue me."[8] Enticed to sit down, and absorb the passion and contemplative spirit of this détourned line and the faux-sunny atmosphere, the spectator, however, begins to feel uncomfortable as the restfulness of the scene is soon mitigated by the intense heat of the lamp and penetrating light. It is impossible to sit on the bench for longer than a few minutes before you're forced to move on; the heat and burning, molten light becoming insufferable. Thus what appears initially to have the seductive appeal of the bright stage-set, upon entering proves to be a kind of infernal illumination; the light and heat quite literally pushes you back out to the margins of the space. Valence provides us with a forest scene 'burning up' through the power of its own ferocious illumination, as if the full force of the Enlightenment's proclaimed dispersal of the dark shadows of ignorance was bleaching its truth into every surface. In these terms this forest scene is, in fact, far from sylvan: the light is not restful, settling, an invitation to thought, but overwhelmingly invasive and blinding. The idea, therefore, that this installation offers a place for Valence's young women to sit peaceably by themselves, to stop and reflect, as opposed to stumbling in the dark, is soon dispelled. The light expels the

body from the space, before the light of reason (of self-reflection) avails itself. But we should be wary of reading this too easily as yet another form of reason's expulsion of women's speech, as if upon emerging into the light Valence's women are unable to orientate themselves. On the contrary, the installation is best read as a *homage* to Rousseau's heteroclite Enlightenment voice, and as such, a reflection on the Cartesian-egalitarian 'solution' to reason, light and the feminine that Rousseau inherits and transforms.

For Descartes the 'natural light' of reason was available to all, putting in question the long tradition (classical and medieval) of philosophy's identification between reason and thinking's escape from the 'nether-world' of the feminine. This is why Descartes places so much emphasis upon the privacy of the mind's reflective operation as a method indifferent to sexual division and the 'passions'. Under reason-as-method's separation of the mind from body, access to knowledge knows no impediment from desire and the will. Indeed, the steady gaze of the reflecting subject enables the thinking subject to transcend the destablizing contingencies of sensuous experience. Method, therefore, for Descartes is an attempt to secure knowledge separate from everyday experience, where body and mind commingle,[9] enabling 'unitary pure thought', as Genevieve Lloyd puts it, to range "like the common light of the sun over a variety of objects."[10] But if this enables male and female to be endowed equally with the powers of reason, nevertheless, Descartes' emphatic separation of mind from everyday sensuous experience and the passions reinforces the notion of the male thinker or philosopher as the best guarantor of this separation. That is, because of the evident gap between this ideal of intellectual equality, and the actual lives of most women (their exclusion from public life and institutions in the seventeenth and eighteenth centuries), it is impossible to transform this equality into actual practice. A double absence is thereby created. On the

one hand, the excising of women's powers of 'unitary pure thought' in actuality; and on the other hand, as a result of the rough equality of men and women – and as such the dissolution of women's secondary intellectual status – the exclusion of women from the enabling realm of the feminine itself. In other words, shared intelligence removes both a working intellectuality for women and the possibility of a 'practical' intelligence inscribed in femininity and female experience. Descartes' abstract egalitarianism, then, despite, its unprecedented break with the secondary character of the feminine, produces its opposite: a continuing subordination of female reason to male reason. This subordination, however, is not on the same terms as the Greeks, who confined the feminine solely to the netherworld. The absenting of femininity in the name of a pure egalitarian unity of thought provides a gap for an anti-Cartesian return of the passions (as in Spinoza), and as such, the reconstruction of the terms under which the feminine is produced as a 'secondary-force-in-unity' with men. That is, after Descartes and Spinoza, the feminine is not a lesser form of reason, but acts as a 'complimentary' and qualitative support for 'men of reason'. "Women's task is to preserve the sphere of intermingling of mind and body, to which the Man of Reason will repair for solace, warmth and relaxation."[11] Thus the rough equality between men and women is based not on evidence of the same, but precisely on difference, on a would-be different kind of intellectual felicity possessed by women, which is, in turn, assumed to be derived from the proximity of women's capacity for the 'renewal of reason' to nature.

It is this capacity of the feminine as renewal of male reason that finds its way into Rousseau's anti-Cartesian Enlightenment critique of abstraction. The feminine is not a stage in consciousness that reason has to exit from, but that which is immanent to the wisdom of nature. So reason, in a certain sense, aspires to the immanent (feminine) authenticity of the natural

world.

Consequently, because of this overwhelming commitment to reason as emergent from nature, Rousseau is considered to be one of the most subjectivist and autobiographical of the *maîtres* of the Enlightenment. His *Confessions* and *Reveries of the Solitary Walker* are works that provide a general psychological framework for a masculine interiority that is framed by the link between nature and a non-dominative (female) reason. Men wrote diaries and confessions, of course, before Rousseau, as a release from or reflection on the passions, as acts of religious contrition and male mortification, but not like this. Rousseau brings a forensic reflection to his motivations, desires and experiences, which is unceremoniously secular and domestic in its intimacy. Indeed, Enlightenment's illumination is utilized, not in order to bring intellectual gravitas and uplift to the work of heroic self-revelation, but as a painful declaration of vulnerability and uncertainty reuniting, in Spinozan fashion, the passions, understanding and the everyday.

> I shall perform upon myself the sort of operation that physicists conduct upon the air in order to discover daily fluctuations. I shall take the barometer readings of my soul, and by doing this accurately and repeatedly I could perhaps obtain results as reliable as theirs.[12]

It is no surprise, therefore, that Rousseau has been thought of as the most 'feminine' of Enlightenment writers – a voice open to the fractures of interiority and the vicissitudes of reason. And it is perhaps no surprise that Valence invokes this subordinate voice as a historical precursor for women's oblique encounter with the light of reason. By encouraging the spectator to sit down, then forcing him or her to move to the margins to continue to view the installation, the spectator sees 'at an angle'; the space of Enlightenment illumination is distorted, made

oblique. Indeed, the female spectator here is provided with respite and a place to look without being observed, whereas the male spectator's prerogative to look and know is made inconvenient; being forced to retreat from the light and heat feels like a provocation and affront. But if Valence produces a spectatorship of the margins in the spirit of Rousseau, her installation is not strictly the 'Enlightenment forest' of Rousseau's reflexive interiority, and as such it provides a détournement of Rousseau the Enlightenment thinker of 'displaced' or naturalised reason as well. As she says in *Feuer Spiel*, Rousseau's famed self-reflection produces a hardened, even paranoid, self-possession in *Reveries of the Solitary Walker*, revealing how fragile his 'feminized', naturalized reason actually is.[13] This is why the obliquity of the viewing position can be seen not just as a displacement of the pure, hard, directional light of Enlightenment reason per se, but also as a deflation of a Rousseauian identification between (troubled) self-possession and the contemplative space of the 'clearing' in nature, so central to the Enlightenment experience of the forest, and to Rousseau's peripatetic reflections in *Reveries of the Solitary Walker*.[14]

In *Reveries of a Solitary Walker*, the clearing (or contemplative space), isolation and self-possession as markers of an authentic naturalism become one, producing a willed asocial mode of reflection and recollection, that again positions a male, albeit interiorized, reason fundamentally outside of men and women's access to a shared relationality and sociality.

> Alone for the rest of my life, since it is only in myself that I find consolation, hope and peace of mind, my only remaining duty is towards myself and this is all I desire... I am devoting my last days to studying myself and preparing the account which I shall shortly have to render.[15]

For Valence, the possession of the 'clearing' in this sense,

therefore, is no solution to the production of reason and subjectivity for women or men, but particularly women, and, as such, the 'absent' reflective figure in the installation takes on a particular force: she refuses to see Rousseau's 'clearing' as a potential autonomous refuge inside the forest, or the light of 'home' on the other side of the forest's edge. For women, a 'room of one's own' is not enough. Hence Valence clears the 'clearing', so to speak. Not in order to start reason and subjectivity anew for women, but to break Rousseau's regressive connection between self-possession, contemplative interiority and the hard light of reason as the force that will clear the forest's shadows and open up nature to this light. If the forest needs illumination, the clearing needs shadows, places for women to hide and to renew reason and the exigencies of speech.

This is why unmitigated and repetitive 'blackness' is no option for Valence as an artist. As she says: "Women artists can't afford total 'blackness'"[16]; there are too many struggles internal to the symbolic to cede space and initiative to the non-representational. Indeed, 'blackness', or even 'whiteness', as a strategy for male artists is, she insists, an incredibly privileged position. To withdraw into blackness without fear of the loss of symbolic value or cultural legibility is to speak from a position of authority, even if the speech is mute, intransigent and withdrawn; something that Ad Reinhardt never acknowledged. This is why there is no absolute 'black sensibility' for women artists, insofar as direct access to the beyond of representation leaves women's speech without any determinate orientation to history and the ontic. To call Valence an artist of the 'night', therefore, comes with an important qualification in the light of the ironized or impossible 'light' in her installation *The Forest of Ménilmontant*. The forest is neither prison nor haven.[17] She therefore rejects the notion that breaking femininity from the neotonic means either taking a path from the forest to the clearing, or, in finding a clearing, there should be no path back to

the forest; there is no straightforward path from darkness to light, from 'speechlessness' to 'speech', from 'otherness' to history; as such 'women's speech' also needs to be able to hide in and disclose itself from the shadows, as much as expose itself to the fierce light of the clearing. The destruction of neotony for women is not a matter of replacing the reification of youth (the feminine as commodity) as 'standing time', with the reification of the feminine as 'without time', of women's time, of a productive namelessness. This is merely diurnal time dissolved into eternity, or the space of the eternal mother.[18] In other words, for Valence there is no pre-symbolic, imaginary solution to women's speech (of an unbounded femininity), no undivided place to be found in either darkness or light, no undifferentiated femininity or *écriture feminine*, no gyno-aesthetics, that would secure the (full) 'speech of women' on the other side of 'male' reason and historical time. There is, only, the positional encounter of the feminine and masculine, reason and non-reason, within the relational and non-relational terms of the symbolic; and, as such, women artists are compelled to signify from inside the interstices of this process. As Toril Moi argues: "We have to accept our position as already inserted into an order that precedes us and from which we can speak: if we are able to speak at all, it will have to be within the framework of symbolic language."[19] The post-symbolic feminine resolution of the speech that is 'no speech', consequently, is a confusion of the promise of women's autonomous and unitary speech with the promise of its release from the force of (male) reason; a post-Enlightenment speech that is haunted by both a Rousseauian 'progressive' enclosure of the feminine within nature, and the pre-Cartesian notion of the feminine as antithetical to abstraction as such. Rousseau for all his attempts to introduce the feminine via nature's wisdom into the compressed borders of male reason – as opposed to letting female intellectuality stand simplistically and abstractedly in Enlightenment terms as equivalent to male reason – again returns

the feminine intellect, like Descartes, to the role of 'enlightened' *subordination*.

Valence's Enlightenment forests, then, can be seen as neither break-out spaces from the netherworld of an opaque femininity, nor spaces of retreat and solace. Rather, they are places where history and the symbolic give a metaphysical shape to women's agency and speech; places where the promise of light, and 'full' reason, and the destruction of neotony, are presented as in struggle with a darkened exteriority that is internal to the shared subjectivity of men *and* women. As such, Valence's are passages to and from light, and from light to shadow; transitional, trans-actional spaces.

It is important, consequently, to account for how the installation form provides the space and cognitive framework for this mode of mediation. Since the late 1970s, the installation has increasingly become one of the key sites for the production and presentation by women artists of 'women's speech' and the critique of femininity and patriarchy, and, therefore, whatever is affectively vivid and interesting about Valence's work derives from this. This is because the expanded space of the installation is able to provide an unprecedented set of material, spatial and cognitive coordinates for a new kind of post-traditional practice for women: namely, a way of working that is irreducible to the reified, specular traditions of the female figurative image, that hitherto has captured the ambitions of many women artists, desperate to find a place within the canon or alternative canon of 'women's practice'. The installation as either three-dimensional work expanded to room-size, or the installation as co-extensive with the extra-institutional architectural locale, provides, in this respect, a fundamental break from these ideological investments, allowing for the construction of radically non-specular production of women's speech separate from the usual humanist default mode of the (painted) female body image. When Rosalind Krauss provisionally codified this new space in 1979, in

her essay 'Sculpture in the Expanded Field',[20] she was only indirectly referring to the conditions of contemporary women artists. Her concern was primarily with the formal extension of art beyond sculpture and painting, in a new form of post-conceptual hybridity, largely outside the gallery. Yet her stress on the cognitive expansion of art as a site of intellectual speculation (what we might call the advent of a new interdisciplinarity in art) is undoubtedly crucial to defining the emergence of this new visual regime and its modes of presentation. That is, the installation – as the formal and systematic concretization of this 'expandedness' – becomes a new Staging Place for the Idea in art, insofar as the installation allows a conjunction of bodies, sound, music, projected image, décor or backdrop, and the readymade. Thus 'expandedness' is here more properly defined as a place of technical, cultural, semiotic conjunction, contiguity and superimposition. Indeed, if at a basic level the theatrical character of the installation guarantees the actual movement or fixed representation of moving bodies, on a higher level the conjunction of image-technology, sound, décor and readymades, extends montage into a performance mode; moving or still images are projected on objects or painted surfaces; participants or performers transform the internal relations and order of elements; objects and surfaces conceal moving or still images; image and sound overlap; and so on. The use of the overworked and facile notion of the *Gesamtkunstwerk* to describe these aspects, therefore, doesn't really grasp this staged and shifting complexity; neither does 'intellectual montage'. This is because what these new forms of installation practice announce is a qualitative technical shift in the distribution and ordering/disordering of symbols, beyond what we conventional identify as the cut-and-paste strategies of two-dimensional photomontage, or the stage-front 'stepping out' of character linked to the alienation effects of Brechtian theatre. The installation, in other words, becomes a form of *three-dimensional* montage in which partici-

pation or immersion in an enclosed space, opened up to sound and image, bodies and representations, allows the customary viewing point of 'reflective distance' associated with the singular object or image to be challenged and deposed, or, more precisely, repositioned; the viewing point of 'reflective distance' is not so much excised as assimilated *into* immersive space.

In this respect, it is significant to note that in *Feuer Spiel*, Valence refers to this new space of the installation, following Hans Jonas's philosophical anthropology, as a kind of *lebens-raum* for women.[21] She doesn't elaborate on this connection, but nevertheless, it brings into focus what makes the non-specular possibilities of the installation qualitatively different from the installation as *Gesmantkunstwerk* and 'intellectual montage'. Jonas talks of *"Wiederherstellung der Lebens psychologische Einheit seinen Platz in der theoretischen Gesamtheit"* ("restoring life's psychological unity to its place in the theoretical totality")[22] through the prioritization of living matter as metabolizing system. That is, matter maintains its identity by allowing foreign (environmental) material to pass through its living form. Matter is never the same, yet persists in its 'sameness'. As such the metabolizing gap between form and matter constitutes the fundamental independence of form from matter; living form is constantly being achieved. This notion of matter-environment as a metabolizing relationship, as an openness of interior to exterior, exterior to interior, is crucial to Valence's understanding of the installation as more than simply an expanded cognitive space. That is, in the movement of participating bodies, of the interconnections of voice and image, of décor and space, the installation becomes a motile setting and passage for looking, hearing and movement, in order that representation, form, voice and space are presented as interconnected elements of a substance without definable borders. Indeed, looking, hearing and moving combine to produce the installation as an integrated and affective 'living-form' that conceivably can take in all manner of contingent and

ambient external materials.

The outcome of this expanded motile and metabolizing function of the installation, therefore, is not simply immersive. On the contrary, the integration of form offers increased capacity on the part of women artists to dialecticize femininity, gender and representation, beyond the antinomies of one and the other. That is, the feminine and representation are produced *out of* the relations and non-relations of the immersive and non-immersive; the non-immersive being contained in, and in tension with, the immersive. The living form of the installation, then, lies precisely in this metabolic potential; in moving across the immersive and non-immersive within the confines of a single constructed space, Valence's figures/voices are able to shift and expose different viewing positions and their connections to power, agency and knowledge; *homo pictor* and *homo faber* combine, disconnect and re-combine.

Accordingly women artists have found this installation form, and its use of immersive and reflective distance viewpoints, to be incredibly productive in opening up a range of formal and cognitive strategies compatible with the non-specular displacement of the female body. In breaking with the singular 'standing' image as the site of a specular and visible femininity – even if that femininity is interrogated and stretched sequentially as in Cindy Sherman's work – femininity is able to step out of the light, of transparent visibility, to adopt non-figurative modes of presentation. This is why the forest, reimagined by Valence as a passage from darkness to light and from light to darkness, is presented as a place of active concealment as much as of forced, unprotected exposure, of non-identitary movement and transposition from sensuous body to intellect, intellect to sensuous body, from image to voice, voice to image. Consequently, the installation, as a living form, becomes not so much the representation of a 'clearing', but is itself a 'clearing'; an ideal 'clearing', that is, insofar as it is able to push aside the moribund requirements of

femaleness, and thereby both stage-at-a-distance and inhabit the dualisms of femininity and masculinity; the creation of a space, in other words, both of demonstrable control and imaginative projection. As such, as the metabolizing and transactional space of the Idea, the installation-as-clearing breaks with the simplistic notion of a 'female aesthetic' to generate something far more telling and productive: the working historical space of women's relationship to the symbolic.

Yet, the troubled relations between the immersive and non-immersive are not solved by the installation as 'living form'. For if Valence's figures/voices inhabit both the immersive and non-immersive, and, therefore, Valence does not expel the female body image absolutely (she continues to include, on occasions, various historical female image-tokens), nevertheless, it is the imagined female body, or absent female body in flight, that dominates the recent installations, and as such it is *vocalization* as negation, as opposed to *visualisation*, that is her preferred mode. The foregrounded voice here frames what we might call the primary encounter of her metabolizing combination, of looking, hearing, moving, intellect and images: the immersive voice that refuses women's inhabitation of identity solely within the image, as a distancing mechanism. Thus if there is no withdrawal from representation per se here – defined as the reactionary modus operandi of a fetishized femininity – the withdrawal from the image, nonetheless, remains the crucial issue, or prevailing trouble spot for Valence. Hence, if the living form of the installation is itself a clearing, there is no ambiguity about what this means overall for Valence: namely a space of reordering and denaturalization. To enter her forests is to know bereftness. This is why if she has no interest in immersion as an autonomous female aesthetic – of flow, multiplicity, the oceanic as the non-dominative – she, all the same, sees immersion as carrying a particular authority and possibility for women artists, and, therefore, as representing a heightened mode of engagement

with denaturalization. Vocalization as immersion provides a non-specular encounter with the female body that places *homo faber* above that of *homo pictur*, and, as such, refuses to return the feminine, as sensuous sign, to nature.

The metabolic and multimedia form of the 'installation-as-clearing' *as* a clearing, then, necessarily transforms our view of the installation as Idea. Immersion is neither the 'liberated' feminine space of post-symbolic indeterminacy, nor a space of new beginnings. Rather, it is the place of the living and constrained (living because constrained) encounter with the feminine and the symbolic. Light and shadow, therefore, are equally constitutive of its reflective demands.

Notes

1 Celestine Valence, 'Interview with Klaus Heinstausen', in *Feuer Spiel*, 3, (1983): p.24.

2 Valence, ibid., p.26.

3 See Valentin Voloshinov, *Marxism and the Philosophy of Language*, trans. Ladislav Matejka and I.R.Titunik (Cambridge. Mass.: Harvard University Press, 1973). See also Toril Moi, *Sexual/Textual Politics: Feminist Literary Theory* (London & New York: Routledge 1985).

4 See Dale Spender, *Man-Made Language*, (London: Routledge & Kegan Paul, 1981).

5 Brothers Grimm, *Kinder-und Hausmärchen* [*Children's and Household Tales*], 7th Edition (Göttingen: Verlag der Dieterichschen Buchhandlung, 1857). This is the edition Valence read as a child. See, *Grimm's Fairy Tales*, edited by Frances Jenkins Olcott, and illustrated by Rie Cramer (Philadelphia: The Penn Publishing Company, 1927). A huge number of the tales are set in a forest, or involve characters passing through a forest, for example: 'The Marvelous Minstrel', 'The Twelve Brothers', 'The Three Little Gnomes in

the Forest', 'Hansel and Gretel', 'The Riddle', 'Little Red Cap', 'The Singing Bone', 'The Maiden Without Hands', 'The Three Languages', 'Thumbling', 'The Robber Bridegroom', 'Thumbling Travels', 'Fitcher's Bird', 'Old Sultan', 'The Six Swans', 'Foundling', 'King Thrushbeard', 'Snow White', 'The Two Brothers', 'The Queen Bee', 'The Golden Goose', 'All Fur', 'Jorinda and Joringel', 'How Six Made Their Way in the World', 'The Fox and the Cat', 'The Singing, Springing Lark', 'The Young Giant', 'The Raven', 'The Spirit' in the Glass Bottle', 'The Devil's Sooty Brother', 'The Wren and the Bear', 'The Sweet Porridge', 'The Two Travellers', 'Hans My Hedgehog', 'The Expert Hunstman', 'The Two King's Children', 'The Blue Light', 'The Lettuce Donkey', 'The Old Women in the Forest', 'The Iron Stove', 'The Lazy Spinner', 'Iron Hans', 'The Three Black Princesses', 'Snow White and the Red Rose', 'The Glass Coffin', 'The House in the Forest', 'The Crystal Ball' and 'The Boots of Buffalo Leather'.

6 Primo Levi, *If Not Now, When?* (New York: Simon and Schuster, 1985).

7 Jean-Jacques Rousseau, *Reveries of the Solitary Walker* (French edition 1782; English edition 1783) trans. and with an introduction by Peter France (Harmondsworth: Penguin 1979).

8 Ibid., p.117.

9 René Descartes, *Discourse on Method and Meditations*, trans. Laurence J. Lafleur (New York: The Liberal Arts Press, 1960).

10 Genevieve Lloyd, *The Man of Reason: 'Male' and 'Female' in Western Philosophy* (London: Methuen & Co 1984).

11 Ibid., p.50.

12 Jean-Jacques Rousseau, *Reveries of the Solitary Walker*, p.33.

13 Celestine Valence, 'Interview with Klaus Heinstausen': *"Rousseau immer fälschlicherweise als Französisch dachte. Er war Schweizer, und er stolz darauf, der als Genfer gedacht werden sollte: Genf, dann, war ein großer Verlagszentrum der radikalen und nicht-konformistischen Denken. Allerdings, wenn seine*

Bücher wurden in Genf verurteilt, 1763 verzichtete er auf seine Staatsbürgerschaft. Seine zunehmende Gefühle der Verlagerung und Randlage in Frankreich, ergab eine Erhöhung des Selbstschutzes, hergestellt schärfer von den wiederkehrenden Gefühle von fehlenden Anspruch im Lichte seines relativ schlecht, handwerklichen Hintergrund. Die Träumereien des einsamen Spaziergängers, *stellt den Zusammenbruch seiner berühmten Selbstreflexions, in eine schrille Selbst Protektionismus. Als Schweizer, ich voll und ganz mit seinem Gefühl, falsch identifiziert (wie Französisch als Deutsch) zu identifizieren. Aber seine späte Selbstbeherrschung erzeugt einen dämmenden Subjektivität der Aufklärung Marge, voller Allmachtsphantasien und Rache. Ich wollte daher, eröffnen diese Verbindung zwischen männlichen Selbstbeherrschung und dem "Clearing" (in der Idee des Freiraums der Kontemplation im Wald verkörpert), das ist so repräsentativ* Die Träumereien des einsamen Spaziergängers*)"*: p.23. "Rousseau is always mistakenly thought of as French. He was Swiss, and he was proud to be thought of as a Genevan: Geneva, then, was a great publishing centre of radical and non-conformist thinking. However when his books were denounced in Geneva, in 1763 he renounced his citizenship. His increasing feelings of displacement and marginality in France produced an increasing self-protection, made sharper by the recurring feelings of lack of entitlement in the light of his relatively poor, artisanal background. *Reveries of the Solitary Walker* represents the collapse of his famed self-reflection, into a strident self-protectionism. As Swiss, I fully identify with his sense of being mis-identified (as French, as German). But his late self-possession produces a deadening subjectivity of the Enlightenment margin, full of fantasies of omnipotence and revenge. I wanted, therefore, to open up this connection between masculine self-possession and the 'clearing' (embodied in the idea of the free space of contemplation in

the forest), that is so representative of *Reveries of the Solitary Walker*)."

14 Heidegger's counter-Enlightenment 'clearing' (*Lichtung*), in contrast, is very different: the removal or dulling of the light of Enlightenment reason opens up a passage to an authentic, premodern truth of being and primordial tradition. *Being and Time*, translated by John Macquarrie and Edward Robinson, (Oxford: Basil Blackwell, 1962).

15 Jean-Jacques Rousseau, ibid., p.32.

16 Valence, interview, p.24.

17 In the 'night' narratives, her female figures never leave the forest, never arrive beyond its border; they walk, to little or no avail. This is as far from flâneuring as an exercise in free movement one could imagine; of walking as distraction and idling, of the comfort of crowds or the comforts of solitariness. In this respect, the forest in its metaphysical and mythic form provides a very different theatre of subjectivity for Valence than the conventional setting of the flâneur: the urban street. The urban stage of the flâneur is one shaped by the *externalization* of interiority, of projection and release, of escape into anonymity, despite the discomforts and privations of the city and the pressures of the crowd. As Charles Dickens, an obsessive night-walker in London, says: "I don't seem to be able to get rid of my spectres unless I can lose them in crowds" ('Night Walks', Chapter 13 of *The Uncommercial Traveller*, London: Chapman and Hall, 1861). Or, as Virginia Woolf declares in her short essay 'Street Haunting: A London Adventure' (1930) from *The Death of the Moth and Other Essays* (San Diego: Harcourt Brace Jovanovich Publishers, 1974), an evening walk on the Strand for her provides an opening to a vital restlessness: "we are streaked, variegated all of mixture" in the face of the distracting tumult of faces, conversational fragments, lights and shop-windows. This releases an un-bordered, liminal

subjectivity: "is the true self neither this nor that, neither here nor there, but something so varied and wandering that is only when we give the rein to its wishes and let it take its way unimpeded that we are indeed ourselves." Valence's dark and morbid forests offer none of this; she may follow the peripatetic Rousseau into the forest, but, in a nocturnal world without distinction, there is no time for attentiveness or distracted self-possession, only time for fear and apprehension. Her character's externalization of interiority exhibits an all engulfing panic or terror; the compressed self closed down to a hard, tight coil.

18 For a defence of liberated women's speech as 'outside of time', see Hélène Cixious (with Catherine Clément), *La Jeune Née* (Paris: UGE, 1975).

19 Moi, *Sexual/Textual Politics: Feminist Literary Theory*, p.170.

20 Rosalind Krauss, 'Sculpture in the Expanded Field', *October*, 8 (1979).

21 See in particular Hans Jonas, 'Evolution und Freiheit', *Scheidewege*, 13 (1983–84).

22 Ibid.

Chapter 3

Sarat Pindar: Dalit Nights (1989)

In Satyajit Ray's short film *Sadgati* (1981), a poor, ill and malnourished Dalit, Dukhi, visits his local Brahmin priest, Panditj, to ask the man's permission to officiate at the marriage of his young daughter. The Brahmin agrees on condition that he does a number of jobs for him around his property: sweeping, clearing away husks and chopping up into firewood a large felled tree trunk. The Brahmin gives him an axe that is blunt and unequal to the task, and, consequently the Dalit is unable to make any headway with the job; even after trying to sharpen it on a stone the axe bounces off the trunk, the surface barely dented. He continues to persevere though, calling up all his (limited) energy in a frenzied attack on its resistant surface. But the intense exertion is just too much for his ill and malnourished body; he collapses and dies. One of the local villagers finds his body and informs the Brahmin, who, with a mixture of frustrated concern and irritation, meets with the villagers to discuss the removal of the body. They refuse, however, to go anywhere near it given its 'untouchable' status, and it is left there during the night, when it begins to rain. The Brahmin under pressure from his wife decides to remove the body himself. He attaches a rope to the corpse's ankle, carefully avoiding contact with the body, and pulls it, in the heavy rain, across a field. At this point, Satyajit Ray leads us to believe that in a Hegelian move the Brahmin, despite his power as a master over the Dalit, is going to dispose of the corpse in a dignified way, and at least show him a modicum of respect, and, as such, break or disturb the caste master–slave relation; the 'unknowingness' and 'spiritualized blindness' of the Brahmin that Ray presents so strikingly at the beginning of the film is, we assume, to be tested. However, the

47

Brahmin's 'concern' is nothing of the kind. He pulls the corpse across the field to haul it to the top of a pyre for animal carcasses, leaving it there to be burnt, presumably, in the morning.

This deranged – and by no means at all atypical[1] – assertion of Hindu caste power is a palpable invocation of caste as a making-waste of bodies, made all the more telling by the Brahmin's refusal to distinguish the Dalit's body from an animal carcass. Sarat Pindar sees this Brahmin reduction of the Dalit body to waste, and its corollary, the Dalit's primary function as waste remover – of the Dalit as the living embodiment and intimate of waste – as the imaginary horizon of all caste relations. Detritus and the cloacal become the living substance of caste relations, the driving principle of 'untouchability' *and* Dalit solidarity.

In the early to mid-1980s, Pindar was photographing Dalit communities in the Maharashtra following a conventional post-FSA documentary line: exposing inequities, and the daily textures of Dalit life, through working in these communities. Living in a number of Dalit villages, talking and sharing food, helping with daily tasks, he was able to produce a number of 'shooting scripts' that, he felt, were sensitive to both the impossible condition and struggles of the inhabitants. But, however complex these photographic sequences were, the resulting images always returned the Dalit body to the realms of the generic exotic poverty-image, the mainstay of humanist and NGO concern in the West about Dalit exploitation. Indeed, the poverty and despair of the Dalit communities appeared indistinguishable from the poverty and despair of non-Dalit peasant lower-caste communities; there were few external signs of Dalit life that were radically different from the general immiseration of the Indian peasantry – agricultural workers and wage labourers as a whole – leaving what did distinguish Dalit communities from non-Dalit communities, such as the Ahirs, in abeyance. This created a growing and compensatory pressure on Pindar's part, therefore, to single out and exoticize where possible those small

local differences and rituals and 'stigmata' that *did* signify 'Dalitness' – for instance, walking barefoot or walking in the shadows so as to remove their 'contaminating' presence for Brahmins close by[2] – in order to give visibility to the absolute abjection of Dalit life.

This feeling of unconsciously contributing to an Orientalist account of Dalit experience was underwritten by Pindar's reading in the early 1980s of Allan Sekula and Victor Burgin, whose critique of the humanism of the conventional documentary tradition in these years has been influential.[3] Both photo-theorists uphold the notion that the reproduction of the powerless body as a political act at the same time inscribed the power of the beholder to look 'without consequence', that is, to take unearned pleasure from the powerlessness and alienation of others. As a result, the critical effect of this looking 'without consequence' is to subordinate political truth to the dissipative effects of humanist empathy. In some sense this was the funda-mental question set by this generation of photographers and photo-theorists in response to the long legacy of documentary practice: *How do I produce a photo-document that disconnects truth from mere empathy? How do I produce a knowledge that is supple-mentary to the truth of resemblance?* But if Pindar was aware of how easy it was for him to become yet another humanist journeyman through Dalit life and the 'Dalit tragedy' – as their sensitive non-Dalit spokesman so to speak – the limitations of humanist documentary practice did not dissuade him from continuing to photograph and work in these communities. Indeed, he recognized how important it was to remain close to those he had got to know, in order to further learn from their experiences, particularly in the light of the huge increase in anti-Dalit attacks across India in the early 1980s, such as the anti-untouchable pogrom in Ahemedabad in 1981 in which many Dalits were killed, fuelled as these attacks were by a growing Brahmin reaction.[4] As he said at the time: "I couldn't leave. There

was too much still to be done."[5] Thus, it was one thing to withdraw photographic consent from the *pathétique* tendencies of humanist empathy in order to question the role of the concerned witness, but it was another to remove oneself from a cultural and political struggle that was in fact barely visible, and, therefore, needed – contrary to anti-Orientalist attacks on the representation of the 'subaltern' – all the intellectual support it could muster. For this reason he also had little sympathy for Gilles Deleuze and Michel Foucault's proto-anti-Orientalist political anti-representationalism in their infamous 1972 interview, which he dismisses curtly in 'In Maharashtra', as a "return to silence."[6] Thus, there is a huge difference between removing the humanist imperative 'to speak for' from photographic practice, and using representation as a means of bringing to knowledge, in which the photographer and his or her subjects *both* speak. Accordingly, there was a continuing imperative on Pindar's part to disclose and give critical weight to a struggle that – through a combination of the sheer bureaucratic ignorance of the National Congress, humanist 'good will', postcolonial post-representionalism, and leftist (Communist Party of India) condescension and evasion on the Dalit question – was exposed to the daily exclusion or derogatory displacement of Dalit experience from public life, economic development and intellectual tradition. To continue to photograph in the villages, then, was above all else an attempt to sustain a working relationship with what had little or no determinate relationship to the political process, and, thereby, give some kind of provisional symbolic shape to these subordinate forces. In this respect, by withdrawing his village photographs from the possibility of public display, Pindar disconnected the process of archivization from the standard role of the peripatetic witness. The archive was no longer an unending repository for the 'telling image' and, therefore, the overarching stem for humanist verisimilitude, but a working image-space that could be utilized for a range of image-construc-

tions not derived from the demands of naturalistic resemblance itself. That is, by resolving to work from the photodocument indirectly, he was able to direct his political and representational concerns to other ends, expressly artistic and figural ends.

However, if this presumes some secondary process of montage, some sequential ordering of image and text, Pindar, did not take the sequential image/text montage route adopted by Sekula, and to a lesser extent Burgin; none of the images he took found their extant way into the work, part or whole. Rather they acted as a preparatory resource – representational cues or symbolic markers – in the way sketches did for generations of pre-modernist painters. Consequently, like a number of photographers emerging from the humanist critique of the photodocument in the late 1970s, he wanted a different order of imaging that only the staged or 'fictive' adaptation of photographic verisimilitude could provide, and that would allow an extended dialogue between photographer and photographed. A big breakthrough on this score was seeing Jeff Wall's work at the Stedelijk, Amsterdam, in 1985 while visiting his brother in the Netherlands ('Günther Forg en Jeff Wall: Fotowerken'), and in the same year, watching Trinh T Minh Ha's film *Naked Spaces: Living is Round* in Delhi, where he was based for a while.[7] Although he had already set up a few staged shots with Dalit workers in his studio, Wall's work opened up a larger frame for an image made as 'constructed realism', that is, a realism that accommodates the non-naturalistic and scenically anomalous or discrepant detail: an 'internal montage'. But he was less interested in Wall's use of actors (or extras), and his cinematic adaptation of this 'internal montage'. Similarly the panoramic scan of Wall's larger, horizontal images was too redolent of Western painterly models. In contrast, Pindar, wanted what he called, "compressed fictiveness,"[8] which allowed him to push a 'constructed realism' into the realm of the grotesque, informal and affective.

The result was his ambitious sequence of constructed images,

Mud-Sea (1–10; each 4ft 6in x 9ft 6in; 1986–88), made in his studio in Amravati. For these ten images Pindar fabricated a huge, clear Perspex container, 18ft wide, 20ft tall and 12ft deep, in which he pumped tons of dark brown/black mud (derived from the black lava soils, or 'black cotton soils' of the area), which he collected from the Wardhi River in the Amravati district in Maharashtra during the Monsoon season (July–October). Before the mud was pumped in, a number of Dalit collaborators from the Mang and Chamar castes in the village of Kardha,[9] where he had been working, entered the Perspex box (through a door) from the rear, holding brooms, shovels and other farm implements. Then the mud was pumped out, to prepare for another scene, and more mud pumped in. In some images the mud would reach waist height, in some little more than a foot, and in some chest height. No more than four collaborators would enter the space at once; in some images male and female would pose in the container together; some images contained four men, some contained four women; the men would wear just loin-cloths, the women traditional Dalit dress, over which they would place the Sacred Thread of high-caste Hindus. In some shots, the collaborators would turn towards the camera, in others Pindar would sustain the fiction of absorption, in Michael Fried's sense,[10] and have the collaborators refuse to acknowledge the camera, engaged in their labours. Absorbed or non-absorbed, however, the mud splashed up from the actions of the figures would cover some or all of their bodies, melding the figures into the mud itself, and in some instances – where Pindar required it – the mud would be thrown up to cover large parts of the frontal plane of the box, increasing the opacity of the scene. In these latter scenes, this opacity would obviously draw direct attention to the picture plane. Similarly, the strangeness of each scene was underwritten by being shot in low light from the rear and from the introduction of red neon signs of single words or phrases in cursive writing three inches high, either below the mud level at the back of the container, or

above the mud level at the back or on the side, such as 'Kiliyuga', (image no. 2) a Hindu term for the deplorable and degenerate nature of the present; 'Jai Ekalavya', (image no. 4) a salutation to the low-caste mythic figure who was ordered to cut off his thumb to prevent him defeating a high-caste Brahmin in an archery contest; and 'Bhangi Mukha' (image no. 7), which means, loosely, 'soil mouth' or 'mouth of the soil remover' (the mouth is crucial to Brahmin mythology, the Brahmins believing that they once emerged from the mouth of the creator; and, conversely, that Shudras – workers and peasants – emerged from the creator's feet, *padaja*). Each neon sign suffuses the space with a red, furnace-like sheen, tightening the range of light values. However, irrespective of these non-naturalistic interruptions, the images reveal no physical trace of the Perspex box itself; the large-format cibachrome photograph is cropped to remove any sense that the scene has a finite edge. Indeed, as a completed sequence, all ten images give the appearance of a continuous flow, or even flood. This is reinforced by the final image, which contains no figures and shows the mud level almost to the top of the picture plane. In a gap of six inches we see the side of various objects (carved from wood) floating on the dark surface, such as shoes, dishes, cups (the kind that Dalit children traditionally would hold out full of water in the morning to passing high-caste Brahmins, in order that they could wash their feet, which were then returned to their parents to drink from before they ate) and the infamous neck pots (familiar from the nineteenth century) that Dalits had to wear if some transgressive or impure offence had been committed.

Where, then, does this kind of constructed image sit within the postcolonial critical context? Pindar's turn to the constructed image is certainly in keeping with moves being made by other photographers/artists, keen to open up the 'symbolic labour' of photography. In this regard Pindar's photographs demonstrate a similar desire to take 'control' of the photographic process in the

studio, as a means of renegotiating and expanding photography's conceptual and artistic identity. But in Europe and North America the critical and political focus of this shift has been played out predominantly through a debate on the critique of realism; the critique of documentary humanism being a stand-in for an anti-realist defence of photography's essential fictiveness. This has led to a growing identification between the constructive capacities of the staged studio image and a post-Kantian sense of (all) photography as a constructed space of the real. The political context of Pindar's photography, however, suggests a quite different understanding and relationship to the notion of constructedness, which is not so bound to the formal and episte-mological concerns of the staged image in the West, given the work's unprecedented novelty and ambitions in an Indian context, and its particular political valences. Pindar may have internalized the critique of humanist documentary practice but the turn to the staged image is not a turning away from either representation or the political embeddedness of photography. Thus, the stakes of constructedness play out in non-standard ways in the *Mud-Sea* series, given the very real specificities of the work's place within postcolonial debate in India, and the work's relationship to the long-standing struggle of the Dalits, and, in turn, the Dalit struggle's own (displaced) place within this context. In other words, Pindar's photographs rise – from their local heterodox conditions of production – to meet, negotiate and refashion the wider and overdetermined space of the 'non-Western' image in its global and imperialist setting. Thus, the very notion of constructedness in this context carries with it a very particular identity and set of ideological tensions, and as such establishes a quite different entry point and exit point for Pindar from the critique-of-representation debate.

As Gayatri Chakravorty Spivak has discussed, with the post-representational drive of recent anti-Orientalist postcolonial theory – exemplified in a related fashion by the Deleuze and

Foucault interview – there has been a crucial failure to distinguish between *Vertretung* (representation as acting for; representative *of*; replication, copying) and *Darstellung* (representation as active depiction, performance, production).[11] This distinction of course, as she notes, was fundamental to Marx's method, *Vertretung* signifying the positivistic presentation of appearances, and *Darstellung* denoting the productive performing of the conflictual and contradictory content of appearances as a movement of identity and non-identity; dialectic as *Darstellungsmethode*.[12] Indeed, *Darstellungsmethode* carries with it the capacity to produce truth as a process of abstraction derived from the inversion or displacement of appearances. As such, the productive-representational function of *Darstellung* lies in the fact that the meaning of one thing is able to be represented by taking the form of another thing – in the spirit of artistic metamorphosis. In fact, isn't something of this method revealed when Marx says famously in a letter to Engels: "Whatever shortcomings they may have, the advantage of my writings is that they are an artistic whole"?[13] That is, the internal relations of the work are *formally* accountable. This is why the translating and abstracting qualities of *Darstellungsmethode* are essentially non-mimetic; truth is the making 'equivalent' of *unlike* things. *Darstellung*, therefore, is representation made formally conscious of its constructive and abstract powers. And, similarly, isn't this what Walter Benjamin highlights in his own reflections on positivism and methodology in the 'Epistemo-Critical Prologue' to *The Origin of German Tragic Drama* (1926), when he talks of "representation of truth" as an "exercise" in form?[14] "Truth, bodied forth in the dance of represented ideas, resists being projected, by whatever means, into the realm of knowledge."[15] Yet, if Benjamin, like Marx, takes it as axiomatic that *Vertretung* is not identifiable with the 'bodying forth' of truth, Benjamin's insistence on *Darstellung* as a kind of renunciation of mere knowledge is clearly not what Marx understands by the 'artistic'

and dialectical character of the abstracting function of *Darstellung*. *Darstellung* for Marx is constructive precisely because its 'world-making' powers are the result of the integrated and systematic reordering of appearance, rather than simply the outcome of the flow and digression of meaning-production away from the surface of things (it is not simply a case of *Umweg*). *Darstellung*, then, captures representation – in its figural, abstract, constructive sense – as doubly articulated: as the act of registering and denotation, and, in turn, the act of de-registering and displacement.

From a wider methodological perspective, consequently, representation-as-*Darstellung* is principally a form of historical and epistemological *staging*, of the bringing forth of the historicity and interdependence of things as a compound disclosure of their truth-value. One can see, therefore, why Spivak is so preoccupied with Deleuze and Foucault's reductive understanding of representation in the postcolonial context, because they clearly fail to account, in their critique of the power relations between 'representor' (literally "representative") and represented, for this double articulation of *Vertretung-Darstellung*. Given that Deleuze and Foucault are so caught up with displacing the privileges of the intellectual from the role of representor – "only those directly concerned can speak in a practical way on their own behalf"[16] – they fail to address representation as the site of a productive tension *between* the reason and interests of the representor and the reasons and interests of the represented across the *Vertretung-Darstellung* divide. That is, by reducing representation to the functions of mere 'speaking for', to mere *Vertretung*, the notion of representation under *Darstellung* as a space for the philosophical (abstract) staging and the performance of things and their relations is made impossible, pushing truth in a compensatory move into the realm of non-representation (where power supposedly weakens or dissolves). Indeed the intellectual-as-representor and represented here, both suffer a

critical collapse. The intellectual-as-representor absolves himself or herself of the problems of mediation and his or her place in the intellectual division of labour, and the represented (those without power) are reinvented, in miraculously fashion, as intuitive bearers of truth, as 'pure', undivided subjects untroubled by the opacities of thought and action. "Representation no longer exists; there's only action," says Deleuze.[17] This is deeply ironic, of course, given, the wider post-Cartesian sympathies of Deleuze and Foucault's philosophical projects. Indeed, as Spivak argues, Deleuze and Foucault's post-representationalism reintroduces the constitutive subject on two levels: "the Subject of desire and power as an irreducible methodological presupposition [as a kind of new revolutionary outrider of Romanticism]; and the self-proximate, if not self-identical, subject of the oppressed."[18] The outcome of this is not just the "absurdity of the nonrepresenting intellectual,"[19] but, more crucially, in a postcolonial context, the reinstantiation of an Orientalist subject at the heart of an anti-capitalist and counter-hegemonic project. For, the fact is that Deleuze and Foucault's post-representationalism concedes embarrassing ground to the notion of the truth and authenticity of the language of the oppressed, as other to 'intellectual speech' and culture, and consequently hoists up the shibboleth of nativist knowledge as untainted by external influences. If this is not precisely the classic Oriental subject of privileged spiritual interiority, never-theless, the subject is rendered equally metaphysical: "mute" yet "omniscient."[20]

The reification of representation as *Vertretung* – as a way of releasing the speech of the oppressed – deeply compromises the notion of representation as a contradictory and conflictual space of interests, weakening representation as an act of staging. As such, this has enormous implications for the debate on photography, representation and documentary, something that Spivak does not address. That is, taking *Darstellungsmethode* as our

dialectical measure, *Darstellung*-as-staging has two significant functions in relation to the truth-performing capabilities, powers of abstraction and constructed content of photographs. Firstly, photodocuments of the powerless, even those that capture the empathy of the humanist spectator in the interests of a pity without consequence, are never solely monological or objectifying in their effects; the subject always speaks back from out of its conditions of subjugation and 'silence', that is, even in its 'muteness' it speaks beyond the given framework of mediation. This means that, although the photographer imposes him/herself on the space of the represented, he does not completely control the terms of that relationship; the *identity* of *Vertretung* is destabilized by the *non-identity* (abstraction) of *Darstellung*. As such, it means that *Darstellung* as a quality of abstraction – of thinking beyond appearances – is immanent to the photograph; photographs don't just speak *of* things, they speak *otherwise*. Or rather, in speaking *of* things they also speak otherwise. And secondly, the staged-image proper – the constructed studio photograph – provides an unprecedented extension of the performed characteristics of representation, an opening-up of the relationship between abstraction and performance as a philosophical encounter. Once the photograph is released from the first-order verisimilitudinal demands of naturalism, a qualitative shift in *Darstellungsmethode* occurs. The conflicted power relations between representor and the represented become constitutive of the act of production itself, and, thereby, potentially a space of collaboration. In other words, as the 'actors' within the constructed drama of the photographic space, the represented, work with and on the process of representation as much as being 'worked on', in turn, by the photographer. Even if the outcome of this process is determined in the end by the photographer's directorial interests, nevertheless, the power relations of the photographic process become co-extensive with the abstractions of *Darstellung* itself. As one of the Mang women,

Jaaibai Kamble, who collaborated with Pindar, was to say after
the completion of the work:

> Mr. Pindar's Marathi was very bad at first. We laughed at his
> questions: "Are you still wear the pots?" But, when he got to
> know us and to know Marathi a bit better, he was able to
> explain what he wanted clearly, and why he wanted to make
> his pictures, and we were happy to help. Some of the elders
> were worried, and a few of the younger men, who were
> sympathetic to the Panthers, objected, but in the end everyone
> enjoyed helping out; some of the young men helped make the
> plastic box. It was good fun in the studio, none of us had been
> in a studio before. He also asked us lot of questions about
> what we should do, and where things should go. We're very
> proud of the pictures, we made them; they are ours.[21]

Thus in freeing photography from the immediacy of the natural-
istic encounter (irrespective of how the photographer in this
context may set up his or her shot in dialogue with the subject,
or how the photodocument is indirectly, non-naturalistically, a
manifestation of *Darstellung*), the photographer is able to stage
the relational conditions of representation as part of the content
of the photographic process. *Darstellung*-as-construction
becomes first and foremost a dialogic and inter-subjective
process, in which conversation and the exchange of knowledge
between representor and represented *precedes* the photographic
act; representation, accordingly, is the very outcome of this
process of exchange. Interestingly, at the beginning of the
dialogue between Foucault and Deleuze, Deleuze, talks of the
representor – the "representative consciousness" – as a multiple.
"Who speaks and acts? It is always a multiplicity, even within the
person who speaks and acts. All of us are 'groupuscules'."[22] Yet,
this multiplicity is a phantasm, outside of the recognition of the
intellectual division of labour, and, therefore, the realities that

shape how knowledge is transmitted and possessed across the class divide. The oppressed can and do represent themselves to themselves and others – no problem – but this is unable to transform itself into an autonomous field of production; for to do so is to transform the oppressed collectively into the very thing that they cannot be, without exiting their class position altogether: namely, independent petty bourgeois cultural producers and intellectuals.[23] In other words, whether the subjugated subject of representation is defined as a multiple or not, self-representation is not the emancipatory gateway out of the intellectual division of labour. On the contrary, the self-representation of the oppressed will necessarily be shaped and delimited by this division of labour as a condition of their collective struggle. This is why the passage of the 'subaltern's' internalization of "representative" consciousness to representation as self-representation is not an exit from the constitutive relations between representor and represented, for the representor brings to the represented not the objective truth *of* their condition, but, the truth of the divisions, blockages and provisional character of representation itself. And this, essentially, is what is 'brought forth' and foregrounded under the auspices of *Darstellung* in the staged photograph, and, in particular, in Pindar's staged photographs: not the truth of the oppressed as such, but the truth of the intimacy between representor and represented, in any given struggle, as an 'ideal' model of learning.

This, in turn, draws us in to reflect on the cognate idea, as in Jacques Rancière's *Le Philosophe et ses Pauvres* (1983),[24] that the creativity of the oppressed is not definable solely in terms of the labour and struggles and everyday experience of the oppressed; the oppressed are no less capable of aesthetic and intellectual judgement and achievement, of leisured indifference, of speculative thought, than the bourgeoisie. *Le Philosophe et ses Pauvres* is devoted to the exposition and defence of this fundamental premise, bringing a concrete set of practices and actions to

Deleuze and Foucault's wholly untractioned critique of 'representative' consciousness from above, but, more pertinently, also bringing a sense that the 'represented' (oppressed) are already possessed of the skills and critical attributes that define their own capacities as 'representors'. "So nothing could be more grotesque than imaging a class consciousness based on the virtue of the labourer. It is not 'doing' that determines being, but the opposite."[25] Pindar's photographs take on the spirit of this; there is nothing to suggest that the dialogue he develops with his Dalit collaborators is anything but a free exchange of creativities.

Consequently, there is a fundamental sense in which Pindar's Dalits are not replicating their daily acts of labour at all, but *re*producing them in a playful act of distanciation. In other words, in 'playing at' what they actually perform as agricultural labourers – exaggerating their movements, fooling around, splashing up the mud, laughing and grimacing – they defy their given identity, as Dalits and labourers. For Rancière such a displacement is crucial to Marx's understanding of class emancipation: "the proletarian is nothing else than the negation of the worker,"[26] that is, the negation of his identity *as* worker. In order to enter "the communist realm of the Many where his free activity will be identified with the leisure of the philosopher," the worker "must become the pure negation of himself."[27] But, the paradox of this negation, perfectly illustrated by Pindar's work, is that his role as privileged 'representor' *enables* this to occur; that is, enables the fictive closure of the labourer *as* labourer to be brought forth and seen, and therefore given political semblance. Without this mediation, of unequal–equal exchange, such playfulness would disappear back into *Dalitness* as such, or the exoticized world of Dalit ritual, evidence merely of the Mang and Chamar being able to 'laugh at themselves'. Rancière's critique of representation as an external imposition under the heading of 'la maîtrise de soi' (self-mastery), then, throws up a similar range of problems in relation to the intel-

lectual division of labour, as with Deleuze and Foucault, even if unlike Deleuze and Foucault he shows, with great philosophical aplomb, the sheer fictionalized character of this intellectual division of labour. Self-mastery can only be truly self-mastery when it is external to mere playful evidence of the labourer as creative agent; when, in short, it takes the *place* of the bourgeoisie. On the other side of this flight from identity – that is, the world we currently inhabit – it remains subject to the externalities of the representor–represented relation. To assume and think otherwise is again to Orientalize the creativity of the subaltern, to assign to it powers and insights it does not, and cannot yet, possess.

These reflections on representation and *Darstellung* have crucial implications, then, for the production of art in the postcolonial context in India, where the radical attack on representation, or the radical and unreflective defense of representation, has acted as a polarizing freeze on debate beyond the antinomies of Orientalism. One should not underestimate, therefore, the objections to Pindar's work from both conservative nationalists and the left – given what the photographs leave behind, culturally and politically – when it was first shown in Amravati in 1988.[28] Pindar's *Mud-Sea* photographs have variously been castigated for their 'abject denigration' of caste values, their ugly impurities, their playful improprieties, and more commonly (certainly on the left) their exploitative, even pornographic, subjection of the Dalit body to mere matter. Indeed, on the second day of the exhibition, the work was physically attacked; yellow paint was thrown over image no. 6 in which four Mang women, wearing the Sacred Veil and covered in mud, are shown jokingly pushing each other around; one of whom, crouching and covered almost completely in mud, stares unselfconsciously out at the viewer. Consequently, this is a debate, about two crucially related issues within the postcolonial context: how and with what does the artist speak in India? And how does the artist, in India and elsewhere in the East and South,

speak to, and beyond, the postcolonial discourse?

One of the great problems facing all artists in India, post-1947 and Independence, has not been how to make oneself modern in the abstract, but how to extract oneself from the overwhelming Brahminic investment and defense of Indianness and Indian culture as a classical religious tradition. This investment seeps through the very pores of caste culture, of Brahmin and non-Brahmin beliefs, making public judgements on cultural value and meaning either an explicit or covert deference to this traditionalism. This is why Pindar's move against the humanist tradition in documentary practice, in its Indian context, is such a heterodox move. For it has been precisely the documentary tradition that has been one of the main secularizing opposition forces to this traditionalism, in contrast to a great deal of modernist painting that has sought to incorporate elements of this classicizing, religious legacy. The humanist subject of conventional documentary practice has stood for, at one level, the rational (parliamentary) achievements of the colonial legacy, of science and sociology in a Nehruvian sense. But, these secular values have themselves easily become ensnared in the debate on Orientalism, given the ease with which secularism/globalized modernity has become a means of excluding the political and cultural heterogeneities of the postcolonial period, expressed most clearly in the political occlusion of the Dalit problem as a problem 'from the past'. "We've all moved on," is the refrain. As a result, secularism/globalized modernity has certainly, through the CPI and left social-democratic forces in Congress, unfortunately been a way of reinforcing the unspoken 'modernizing' Brahminic hegemony: language, caste and village culture are seen as archaic residues. In this light, one of the things that the CPI has never directly addressed is the Party's almost total Brahmin leadership, and the fact that very few Dalits have ever joined the party, even in the unionized textile areas (this is why the Naxalites, as a Maoist split from the CPI, have won so much

Dalit support in the countryside). And this, in turn, has fed the anti-Western rhetoric of the postcolonial debate. Given the fact, according to the postcolonial position, that India is an exceptional developmental case (that is, it has been unable to truly and fully modernize and thus incorporate its subject peoples into a bourgeois democratic polity), capitalist development doesn't apply in the same way in India as in Europe and, as such, does not need to take the same modernizing route as the West. Given the Indian state's weak incorporation into the global circuits of capital, and given the Indian people's historic and living intimacy with pre-capitalist forms, the people are best placed to find a non-Westernized path of development.[29] In this respect much of this thinking is rooted in a misconception of the Indian countryside as external, or incidental, to the accumulation process. On the contrary, since the mid-nineteenth century so-called Indian rural backwardness – the production and export of cotton and jute – has been one of the primary agencies of the expansion of the global market; the basis, in fact, upon which British capitalism was able to flourish. Indeed, as John Merrington argues:

> [T]he tendency to see in rural backwardness an obsolete, precapitalist survival, external and inimical to capitalist development, overlook[s] the numerous cases where this backwardness was quite functional to the overall process of accumulation.[30]

In these terms, Indian rural cultural and social underdevelopment, and the maintenance of premodern forms and customs, is a result of the penetration of the global market and accumulation process *into* the countryside. As twentieth-century capitalism has repeatedly shown us, imperialist modernization produces underdevelopment, dependency and immiseration for subject peoples at the same time as it raises productivity and the

technical proficiency of labour.

The pastoralist separation of the countryside from capital accumulation and 'Western' modernization in contemporary postcolonial thought, then, is a postmodern version of Gandhism, albeit without the dogmatic metaphysical attachment to caste, as in Mahatmi Gandhi's reactionary politics of Sharir Yayna (the return to the village spinning wheel and the Varna system)[31] that Bhimrao Ramji Ambedkar (1891–1956) fought so hard against in the 1930s and 1940s on behalf of both Dalit liberation and secular modernization. As Ambedkar asserts: Dalits and agricultural labourers have no collective interest in colluding with the myth of the premodern, and therefore with the notion that Dalit and peasant needs have a particular autonomy and are irreducible to class. Dalits and landless agricultural labourers struggle within, not outside, the divisions of modernity, given, that their modern conditions of labour are the outcome of modernization and the accumulation process. "The object of the *Varna* system is to prevent competition and class struggle and class war."[32] (*Varna* being the old birth-given caste divisions of Brahmin (Spiritual leaders), Kashratiya (Warriors), Vaishya (Merchants), Shudra (Workers, Peasants).) Indeed, we might say there is a return of the repressed. Today, as in the 1930s and 1940s, the CPI and Congress left-democrats have tended to see the Dalit struggle as diversionary, in the interests of an abstract modernization in which Dalits are encouraged to leave their premodern customs and fealties behind, as those who support Dalit emancipation are encouraged, in turn, to subordinate Dalit interests to the secular demands of a wider struggle. This has swerved between a 'pure class' perspective, focused solely on the (relatively small) industrial working class in the big cities, and a national-unity perspective that puts shared cultural attributes above inter-caste strife. In this respect the CPI and many CPI aligned Marxists see caste merely as an epiphenomenal form: behind the appearance of caste ultimately lays the

reality of its class content.

Consequently, by refusing to extract the class essence of caste form – by conceding to its autonomy – the focus on caste is seen as retarding class struggle. The only Marxists and radicals to resist this line have been the Naxalites and those in the Dalit liberation struggle (such as the Dalit Panthers) who are indebted to Ambedkar's politics from the 1930s. Both have pursued a 'class-caste' approach in which caste and class are held to be interdependent. But as Amedkar's experience in the 1930s and 1940s reveals, when he led the Independent Labour Movement Party (1936–42), the multitudinous lower sub-castes are not easily constructed and organized as a dominated category; lower-caste allegiances are invariably split across religious, cultural and craft lines. Yet Ambedkar's position from that period remains sound: the basic political guideline should be: *who* are the exploiters and *who* are the exploited? In this respect we do not *begin* with the complexities of class as a relational category, but with the specific form in which unpaid surplus labour is pumped out of the direct producers. Thus, given the fact that caste hierarchy defines the relations of surplus extraction, the anti-caste struggle is also a key site of class struggle; the class fight against exploitation takes place *through* caste, village communities, and kinship ties. This is why, as Ambedkar argues, as the most proletarianized layer of the exploited – in the 1971 census, it was found that 52 per cent of Dalits were landless agricultural labourers – Dalit workers have the potential to play a leading role in uniting other castes around particular struggles. The claims, therefore, made by both the CPI and left social-democrats in Congress, that the Dalit struggle is 'sectarian', and a petty-bourgeois deviation, is misguided. On the contrary, the 'caste-class' front is the very form through which the antinomies of modernization and postcolonial theory can be addressed without both politics and cultural politics falling into the trap of Orientalism.

One can see clearer, then, why Pindar has invested so much

artistically and politically in the staged image as a space of figural, constructed representation in a political and cultural context where boundaries, borders and deathly hierarchies elide Orientalism with its own critique, to produce a warring collision of inert identities. *Darstellung* allows a space for artists and intellectuals to challenge the narratives and modernities of developmental secularists, religious traditionalists and postcolonialists, modernism and postmodernism alike. For, the playing out, and playing with identity, under the auspices of the internal instabilities of the representor–represented relation, itself invites the production of an image without the usual ideological props of the 'other' or 'communal/national belonging'. In this respect Pindar's images break with both a post-Bandung (1955) Third Worldism, in which East and West are held up as civilizational others, and the crass modernizers who, in attacking Third Worldism and the civilizational roots and ancient revivalism of the dominant Hinduism, dismiss the heteroclite cultures of caste in the same breath, thereby separating the struggles of Dalits over language and culture from class struggle and modernization altogether. As such, the use of mud plays a particular deflationary role here. Mud is both the ancient nescient form of caste ideology (the blockage or absence of knowledge), and the indefatigable substance of Dalit solidarity, its living impure matter, the substance whose opacity resists the *indiscriminate profusion* of Hindu and Brahminic light, as in Gandhi's upper-caste (Vaishya) reform Hinduism. Gandhi's invidious desire to incorporate the Dalits (or what he called the Harijans) into the greater light of the Vanta castes, was not so much an emancipation from the fetters of the past as an attempt to cleanse Hinduism of its 'impurities'. (According to the ancient Sanskrit scriptures, the Vedas, Dalits are considered to be neither Shudras *nor* Hindus; truly mud, truly beneath the creator's feet themselves.)[33] But, if this Brahminic light seeks to burn up the embarrassing rituals of 'untouchability', it is also the light that

obliterates Hinduism and the past. For Hindi is itself a borrowed 'mud' word, an impure, heterodox residue of the past and 'otherness'. 'Hindus' was the name given by ancient Muslims in India to the natives they encountered.

A cultural politics is opened up here that resists two positivisms: the reduction of secularism to the abstract logic of mere developmentalism, and, conversely, the revival of an Indian exceptionalism under the auspices of a postcolonial Third Way, with all its obscurantist ideological baggage, derived from either the ancient past or from contemporary modes of anti-Western, postcolonial 'spiritualism'. If each position dissolves Dalit identity, from very different viewpoints, and leading to very different politics, nevertheless both result in one invidious outcome: the unspoken maintenance of Brahmin privileges and the Brahminic leadership of modernization and the democratic and social struggle. Thus the specificities of caste are key to the struggle against this hegemony. For without the link of caste to class, and caste and class to the removal of ancient fealties, the national culture will always secure the rationalism of the dominant, *over* the rationalism of the dominated. To define the Dalit problem, therefore, as something that is best assimilated or excluded (renamed) in the name of progress or the modern, removes what is essential to the transformative democratic and emancipatory potential of the Dalit struggle itself; for to truly break the bounds of caste for all, it is those who have no investment in it – the majority – who will determine the conditions of its dissolution.

What is at stake for the Indian artist, therefore, after Third Worldism, archaic Brahmin ethnicism and abstract developmentalism? What is released by the breaking of the links between humanism and Brahminic hegemony? Clearly: an attachment to the modern that offers a non-exceptionalizing and internationalizing point of entry for the artists into the circuits of global capitalism. Indian artists are obviously no less part of these

circuits than European and North American artists. Yet, this point of entry, of course, remains intractably uneven given Anglo-American imperialism, and the relative weaknesses of Indian capital. Indian artists have not suddenly joined, a One-World Art Club, nor would they want to. Thus, even if the modern Indian artist is indistinguishable, in his or her uses of advanced theoretical resources, from European and North American artists, (as Pindar exemplifies) the Indian artist is still subject to the capital-imperialist relation in ways qualitative different from Europe and North America. As Aijaz Ahmed puts it: "countries from the three continents have been assimilated into the global structure of capitalism not as single cultural ensembles, but highly differentially, each establishing its own circuits of (unequal) exchange with the metropolis, each acquiring its own very distinct class formations."[34] As such the Indian artist's relation to the modern – the Indian artist's investment in, negotiation with, and resistance to this concept – is the outcome of this fundamental relation. Indeed, the Indian artist's claim *on* the modern will be conditioned by the ways in which this relation is experienced by artists and cultural producers, not simply as an uneven *opportunity*, but as a deter-mining *externality*. That is, what might be made of the modern, of its possibilities, aporias and intractabilities, will be the result of this exchange.

Modernity and internationalization, then, still feel very different in Delhi and Amravati than they do in Berlin and New York. But one might add: *necessarily* so. Consequently, the broader demand of *Darstellung* under these conditions will involve a wholly new constructedness, or more precisely, positionality, from the artist. The achievements of the metropolis are no longer to be imitated in a would-be gradual diminishment of the gap in accomplishment between centre and margin, but relativized, according to the emergent (and anti-imperialist) modernizing claims of the periphery. The periphery, then,

remains the periphery so to speak, under the capital-imperialist relation, but the symbolic tasks it completes, and critical relations it establishes with the centre, will by definition challenge the self-identity of the centre. That is, under these newly modernizing conditions of the periphery the centre can no longer assume absolute control over the content of modernization on a global basis; there can no longer be a singular radiation of the modern from the centre to the periphery. This shift requires, therefore, more than the advance of a new kind of global 'cognitive mapping' on the part of the artist, as Fredric Jameson declares.[35] It requires a wholly new post-periphery-centre dialectic, in which the artist of the periphery works across two interconnected models of re-spatialization: firstly, a reordering of the global circuits of modernity through the internationalization of cultural, historical and cognitive resources of the artist; and secondly, the *non-identitary* investment by the artist in this process of modern-ization as a condition both of the uneven national entry of the artist into these modernizing circuits, and, the artist's political resistance to the modernizing *displacement* of the native or indigenous mediation of these new circuits of modernity. This dual social and cultural positionality of the Indian artist derives, therefore, from two sets of external and internal conditions that necessarily underwrite the demands of respatialization generally: the exit of art from Third Worldism on the basis that India and its subject peoples are no less subordinate to the forces of global capital than any other country, and, crucially, the recognition that the place of native subject-struggles *defines* the ways in which these modes of engagement position India and its artists – and its claims on the modern – within these circuits of exploitation. The distinctiveness of Pindar's *Darstellungsmethode*, accordingly, is that it opens itself up to this dialectic at the level of the anti-Orientalist 'nativist-modern' image; whatever kind of symbolic relation the work has to 'Indianness' in the current period derives from this. Yet, *Darstellung* is not a magic bullet for artists of the

periphery, or anywhere else for that matter. The constructed image may enable a new kind of postcolonial spectator to emerge, one not beholden to the concerned humanist or the traditional (religious) aesthete, but its constructedness is only convincing to the extent that contradiction and conflict are worked through, as a matter of the artist's reflection on the externalities of his or her own (global) positioning.

Notes

1 Indeed, this violent disregard could be said to be shockingly commonplace, as is reflected in the popular song of the Dalit Liberation Movement, 'Marathwada Is Burning': "Accosted in the fields, tied with a rope / His hands and feet branded, then thrown in the fire / He burned fiercely, the son of Bheem" [the 'son' of Bhrimrao Ambedkar], quoted in Barbara J. Joshi, *Untouchable! Voices of the Dalit Liberation Movement* (London: Zed Books, 1986): p.98.

2 For a discussion of a range of these prohibitions, see Govind Sadashiv Ghurye, *Caste and Race in India* (London: Routledge and Kegan Paul, 1932) republished by Popular Prakashan, Mumbai (1979).

3 See Victor Burgin, 'Looking at Photographs' (1977) and Allan Sekula 'On the Invention of Photographic Meaning' (1975) in Victor Burgin, ed, *Thinking Photography* (London and Basingstoke: MacMillan Press, 1982). For a discussion of Pindar's relationship to the documentary tradition, see Sarat Pindar 'In Maharashtra', *New Photography in India*, 2:3 (1986).

4 This follows, of course, constant violent oppression since Independence: in particular the Congress-directed anti-Dalit pogroms in 1948 (before Congress's left-turn in the early 1950s) which left 2000 Dalits dead, 300,000 tortured and 5000 imprisoned; and the massacre of 44 Dalit agricultural labourers in Kilvenmani village, Thanjauver district, in 1968.

5 Pindar, 'In Maharashtra', p.16.

6 Michel Foucault and Gilles Deleuze, 'Intellectuals and Power: A Conversation between Michel Foucault and Gilles Deleuze' (1972), in Michel Foucault, *Language, Counter-Memory, Practice: Selected Essays and Interviews*, trans. Donald Bouchard and Sherry Simon (Ithaca: Cornell University Press, 1977).

7 Between 1985 and 1987 Pindar was part of a group of artists and writers in Delhi, *Misra Bhojanan*, which included dissident communists, Naxalite supporters and a number of postcolonial theorists, who all took the political and cultural 'invisibility' of the Dalit struggle as a symptom of a wider Brahmin cultural repression.

8 Pindar, 'In Maharashtra', p.17.

9 The Mang caste lives in the Northern states, in particular Maharashtra, and are predominantly leather curers, hangmen, midwives, village musicians and ropemakers. The Chamars also live in Maharashtra and are tanners and shoemakers. However, it has been the Mahars (dockworkers, millworkers, factory workers, railway workers, in the big cities), Malas (village watchmen, domestic labourers, agricultural labourers, from Southern India) and the Holiyas (agricultural labourers, from Karnataka State) that have made up the main social base of the Dalit liberation movement in the twentieth century.

10 Michael Fried, *Absorption and Theatricality: Painting and Beholder in the Age of Diderot* (Berkeley: University of California Press, Berkeley, 1980).

11 Gayatri Chakravorty Spivak, 'Can the Subaltern Speak?' in *Marxism and the Interpretation of Culture*, ed. and with an introduction by Cary Nelson and Lawrence Grossberg (Urbana and Chicago: University of Illinois Press, 1988): pp.271–313.

12 See Hans Friedrich Fulda, 'Dialektik als Darstellungsmethode

von Marx', in, *Ajatus*. Suomen Filosofisen Yhdistyksen vuosikirja, 37 (1978): pp.180–216. Theorization of *Darstellungsmethode* is well advanced in the German tradition; in Anglo-American Marxism it is rarely addressed. Even Derek Sayer's otherwise excellent *Marx's Method: Ideology, Science & Critique in 'Capital'* (Hassocks Sussex and Atlantic Highlands, New Jersey: Harvester Press, 1979) doesn't broach the subject, nor does Sean Sayers in *Reality & Reason: Dialectical and the Theory of Knowledge* (Oxford: Basil Blackwell, Oxford, 1985).

13 Karl Marx, Letter to Engels, 31st July 1865, Marx and Engels, *Collected Works*, 42: Letters 1864–68 (London: Lawrence & Wishart, 1987): p.173.

14 Walter Benjamin, *The Origin of German Tragic Drama*, trans. John Osborne, introduction by George Steiner (London: New Left Books, 1977): p.28.

15 Ibid., p.29.

16 Foucault and Deleuze, 'Intellectuals and Power', p.209.

17 Ibid., pp.206–7.

18 Spivak, 'Can the Subaltern Speak?', p.279.

19 Ibid., p.288.

20 Ibid., p.275.

21 'Amarāvatī kalākāra dalita kārya karatē' ('Artist in Amravati Works With Dalits'), (*Lōkamata ṭā'imsa*) (*Lokmat Times*), December 13th 1988: "*Śrī Pindar marāṭhī prathama phāraca vā'īṭa hōtī. "Tumhī ajūnahī bhāṇḍī bōlatā āhāta?* " *Tyānē marāṭhī āmhālā jāṇūna āṇi cāṅgalē thōḍā māhita ālā, tēvhā tō spaṣṭapaṇē hōtē kāya hē spaṣṭa karaṇyāsāṭhī hōtī, āṇi kā tō tyācyā citra hōtē: Āmhī tyācyā praśnāncī thaṭṭā āṇi āmhī madata ānanda hōtē. Vaḍīladhārī maṇḍalī kāhī kāḷajī hōtī, āṇi pamtharsa, ākṣēpa sahānubhūtī asalēlē taruṇa puruṣa, kāhī, śēvaṭī pratyēkajaṇa dhyēya madata ānanda; taruṇa mānasē kāhī plāsṭika bŏksa karā madata punarāvalōkana karēlā. Āmhālā kŏṇīhī ādhī ēka stuḍi'ō - gēlē hōtē, stuḍi'ō madhyē khūpa majā hōtī. Tō vēba āmhī shoulds*

73

kāya baddala sā'iṭa āmhālā samasyā bharapūra, āṇi gōṣṭī jāṇāra āhē, tikaḍē. Āmhī'ēma kēlī, citrē atiśaya abhimāna vāṭatō; tē asvala āhē."

22 Deleuze and Foucault, 'Intellectuals and Power', p.206.

23 For a discussion of the structural impossibility of workers' *collective* exit from the proletariat, see G.A.Cohen, 'The Structure of Proletarian Unfreedom', in *Philosophy and Public Affairs*, 12, Winter (1983).

24 Jacques Rancière, *Le Philosophe et ses Pauvres*, (Paris: Librairie Artheme Fayaes, 1983).

25 Ibid., p.80.

26 Ibid., p.81.

27 Ibid.

28 *Mud-Sea*, Sophrosune Gallery, Amravati, September–October, 1988.

29 Ranajit Guha, 'On Some Aspects of the Historiography of Colonial India', *Subaltern Studies 1*, Oxford University Press, Delhi (1982): pp.1–8.

30 John Merrington, 'Town and Country in the Transition to Capitalism', in Paul Sweezy et al, *The Transition from Feudalism to Capitalism*, introduction by Rodney Hilton (London: Verso, 1978): p.193.

31 See Garathi Journal, *Navan-Jivan*, (1921–22). "Hereditary principle is an eternal principle... It will be chaos if everyday a Brahmin is to be changed into a Shudra and a Shudra is to be changed into a Brahmin." In the 1930s his thinking, under the secular pressure of the anti-colonial movement, shifted to a conservative reform of Hinduism; some women from the lower castes should be able to marry into higher castes, and Dalits should be allowed to become Shudras. However, the necessary 'harmony' of the separate castes remained; no individual should aspire to a profession or craft outside of his allotted caste; some (male) Dalits should receive an education, but no Dalit should make a living from what he

has learned.

32 Bhimrao Ramji Ambedkar, *What Congress and Gandhi have done to the Untouchables* (Bombay: Thacker, 1946). See also 'Annihilation of Caste', presidential address for the annual Hindu reform group, *Jat-Pat Todak Mandal* (Lahore: self-published, 1936).

33 See V.T. Rajshekar, *Dalit: The Black Untouchables of India*, foreword by Y.N. Kly (Ottawa: Clarity Press, 1987).

34 Aijaz Ahmad, 'Jameson's Rhetoric of Otherness and the "National Allegory"', *Social Text*, 17, Fall (1987).

35 See Fredric Jameson, 'Postmodernism, or the Cultural Logic of Late Capitalism', *New Left Review*, No 146, July–August (1984): pp.53–92.

Chapter 4

James Fendel and Christian Flaherty: "We find, we count, we sort" (1990)

What kind of truths can we bring to the artwork? Chemical truth? Interstitial truth? Extensional truth? Micro-spectrometric truth? Set-theoretical truth? All these truth procedures are certainly capable of revealing a range of material, architectonic, formal and logical processes at work in any given artwork: of rendering visible like and unlike, of hidden, significant structural patterns. But why aren't we satisfied with these procedures and their truths? Indeed, why are we actively resistant to their insights in relation to art? Why does the prospect of reducing Rembrandt's painting to a diagrammatic chart of its chemical components as a claim on its perspicacity appear risible (unless you're a restorer) and painfully obtuse? Why would the micro-spectrometric analysis of a Brancusi, as evidence of the work's fascinating morphological 'inner tensions', be absurd and deeply unappealing? In fact, something of this 'comprehension' problem that mathematical science brings to the *meaning* of objects, particularly artworks, is summed up by the nineteenth-century mathematician Bernard Belzano's definition of a set: the "embodiment of the idea or concept which we conceive when we regard the arrangement of its parts as a matter of indifference" [*Gleichgültigkeit*].[1] In other words, what distinguishes mathematical science's understanding of 'wholes' is properly its formal disregard for the heterogeneous and relational content of the components under review. This seems to be the non-hermeneutic fate of scientific enquiry into artworks: micro-materialist, abstract-formal, or topological accounts of artworks bring a range of truths that, because they are highly localized in value, fail to support any plausible or worthwhile interpretative claims about

artworks, and as a result fail to facilitate the experience that observers expect to obtain from looking at art. Thus, the application of the scientific knowledge of micro-processes or extensional relations to an understanding of an art object or event is not just reductive – quite obviously – but objectively *arbitrary* and, therefore, directly injurious to the intelligibility of the work and its cultural meaning. In the same way, if we were to accredit the value of a work according to its carbon content, as a means of monitoring and assessing the artwork's 'ecological profile' – low carbon content good, high carbon content bad – we would be accused of applying adventitious criteria to the artwork. Indeed, we would be accused of being outrageously inappropriate, mystificatory, even weirdly and comically abusive towards the artwork's integrity.

Such truth procedures, then, represent a violation of what is necessarily non-arbitrary about the connection between sensuous appearance, semblance and the constitutive semiotic/material components of the form of the artwork and the recovery of historical and symbolic meaning – the fact that the abstract-theoretical evaluation of the significant and determinate relations of the artwork will be based on the genetic-causal explanation of its human-produced (authorial) appearance; nothing – or little – revealed from the mathematical and chemical processes underlying these appearances will add to this content. The use of mathematical knowledge doesn't *ipso facto* exclude the recovery of such meaning – in some instances it may support it – but, once it takes on an autonomous function, it makes it very difficult to bring such knowledge into constructive alliance with the genetic-causal production of cultural and symbolic meaning. So, scientific knowledge may occasionally be an under-labourer for the work of artistic judgement, but it can never determine judgement, without, that is, leading to incoherence.

Yet, despite all these obvious shortcomings in the scientific (physicalist) evaluation and interpretation of art, art in the

modern period has wanted some stake, some working place in the universe of mathematical and scientific truths, and attachment to the prestige of *Gleichgültigkeit* – certainly as *practice*. We see this beginning with art's intimate collaboration with the 'science of architecture' and mathematical science in the Renaissance, and later with the architectural turn of Constructivism in the Soviet Union in the 1920s, and the painting of Malevich and Piet Mondrian, down to the use of formal systems and extended geometric grids, patterns and motifs in post-Constructivist art (Theo van Doesburg and *Art Concret*) and in the minimalism geometries and the indexical and archival practices derived from the readymade of post-60s art today. However, if the Renaissance and Constructivism draw on the science of mensuration and architectonics and the notion of the artist as multidisciplinary technician, since the 1960s there has also been a systematic drive to *de*-subjectivize the link between meaning production and the materials of artistic production, in keeping with the broader post-Duchamp excavation of the expressive monad from artistic practice and judgement. The artist, in these terms, becomes not so much a multidisciplinary fabricator of *useful* things (in the Renaissance-Constructivist mode), as a vector of post-authorial and post-expressive technical proficiency; a quasi-machinic subject of structured *Gleichgültigkeit*. Indeed, Duchamp's readymade can be read as the mathematized core of this displacement of conventional authorship, given its explicit destruction of the conflation of authorship with painterly or hand-directed expression, through the valorization of the artist who counts, orders and selects, and the subordination of the artist's skills to art's extended division of labour (the completion or production of the work by others on the artist's instructions). Indeed, Duchamp's *Fountain* (1917) is perhaps the first work in the history of modern art where the (basic) procedures of set theory – a set being that which is produced through the iterated application of the operation 'set

of'[2] – becomes a way of modeling an expanded non-standard account of objects definable as art and a non-standard understanding of creativity. So, if scientific *Gleichgültigkeit* cannot *explain* art, nevertheless, how might it shape the post-Duchampian critique of artistic subjectivity?

Fountain is a classically mathematizing move on the grounds that it extends the terms of set inclusion of art, precisely the set 'nineteenth-century art' that Duchamp inherits. But Duchamp's extension is based not simply on the notion that the urinal is now part of an expanded set of artistic objects known as 'early twentieth-century art' ('twentieth-century art', incorporating the set 'nineteenth-century art'). For given that the urinal is itself a set – insofar as in this case 'urinal' designates a set of all things urinal-like as art – it is not therefore simply a subset of 'nineteenth-century art' ($A \, AB$). This is because the urinal as a set of all things urinal-like as art, enables other non-artistic predicates to enter the set of non-art art-like things, thereby not simply extending the set 'nineteenth-century art', but transforming the very conditions and terms of inclusion of art-like things in the governing set. That is, if in the wake of Duchamp's radical rupture all non-art predicates are able to enter the domain of non-art art-like things, then the hierarchies and terms of inclusion and exclusion of the set 'nineteenth-century art' are irredeemably *transformed*, not just extended. In other words, the predicate 'urinal' collects in its 'set inclusive' wake an infinite number of other non-art things as art-like things, which, accordingly, fundamentally alter the relations of inclusion into the set 'nineteenth-century art'. The set inclusion is now reversed: $B \, AA$. *A explains B, rather than B accommodating A.* In a different register we might describe this assimilation of B into A, and, as such, the radical transformation of the *meaning* of B, as Hegelian, insofar as it produces a retroactive explanatory move, in which the emergent set generates a new set (a new fundamental predicate), that in turn converts the superseded set to a sub-set of the new

set – or conceptually null set or Empty set[3] – on the grounds that the superseded set can no longer incorporate the new set without contradiction. The superseded set has to 'give way', so to speak. And this is what we might mean by the *Gleichgültigkeit*-mechanism of set inclusion. This new post-Duchampian set does not provide an aesthetic judgement on the superseded set (although some might want to see this as so in the light of what Duchamp says about painting), as if the *achievements* of nineteenth-century art had themselves been superseded (rendered indifferent), but rather that the set 'nineteenth-century art' is unable, convincingly, to give meaning to the historical demands and horizons of the new set. It therefore becomes a (non-explanatory) set without the capacity for expansion and the assimilation of other sets. Yet this is not the end of the matter logically and conceptually. If the set 'post-Duchampian' art, as a subset of 'twentieth-century art', fundamentally transforms the set 'nineteenth-century art' – the imagined telos of nineteenth-century art now is only comprehensible in the light of the break of the set 'twentieth-century art' – the predicate 'urinal' as a non-art art-like thing immediately undergoes a collapse. This is because not all urinals as art-like things can possibly *be* artworks, indeed, emphatically, only one can – the original, which ironically was never exhibited publically, and only exists in the form of Alfred Steiglitz's well-known studio photograph. For to simply repeat the act of nomination is to confuse the general truth of the incorporating set (unassisted readymades, such as urinals, can stand as artworks) with the specific and determining truth of Duchamp's urinal as a discrete work of art: there can only be one extant urinal as a non-art art-like thing, Duchamp's; all other urinals as unassisted readymades would simply be academic copies, just as producing other unassisted readymades, as if the original did not exist, would fall into the same trap.

'Duchamp's urinal as a non-art art-like thing', therefore, remains quite separate from the set 'post-Duchampian art' as an

identification of non-art with art-like things, insofar as it presup-
poses a set of qualities and attributes that subsumes, challenges
and qualifies the sets 'nineteenth-century art' and 'twentieth-
century art' equally. That is, if the set 'nineteenth-century art' is
discontinuous with the set 'twentieth-century art', the set
'Duchamp's urinal as a non-art art-like thing' is itself discon-
tinuous with the set 'twentieth-century art', and, therefore, with
the notion that the readymade is simply a further exemplar of
the artist as indomitable creator, even one as perversely
heterodox as Duchamp. This is because the singular set
'Duchamp's urinal as a non-art art like thing' is not just part of
the expanded set *artworks* in the twentieth century', but one
particular important instance of a range of techniques that
dissolve the traditional identity of artwork and artist *presupposed*
by both sets 'nineteenth-century art' and 'twentieth-century art'.
In other words the urinal, as non-art art-like thing, is part of a set
of readymade *techniques and practices*, which fundamentally
alters not just what gets into the set 'twentieth-century art', but
how the set 'twentieth-century art' qualifies as *qualitatively*
different from the set 'nineteenth-century art'. Consequently this
set, which we might call the 'technical separation of art from the
expressive hand and singular authorship', (TSAEHSA) aligns the
'urinal as a non-art art-like thing' with other instances of
technical *Gleichgültigkeit*, such as photography, film and the
archive (as the structural expression of the readymade), to form
another set: 'practices that evidence the radical transformation of
art's place in the technical and intellectual division of labour'.
(PERTATIDL). In this sense, PERTATIDL establishes – at least for
our argument – a determining additional membership-relation
for the set 'urinal as a non-art art-like thing', insofar as
PERTATIDL accommodates all the other membership-relations
possessed by the set 'urinal' in the given chain ('twentieth-
century art'; 'Duchamp's urinal'; 'post-Duchampian art';
'artworks in the twentieth century'; 'TSAEHSA'). In other words,

it provides an increase in content-membership for the set 'the urinal as a non-art art-like thing', *over and above* the other sets. But, of course, whatever expanded content this provides, this set will nonetheless provide the basis for further operations of the 'set of.'

To apply such set-consciousness systematically to art, of course, may clarify art's various productive, historical, cultural, technical and cognitive membership relations. But this has not been the primary concern of the artist after Duchamp or their interest in *Gleichgültigkeit*, even if they may take a certain reassurance from the membership-relations outlined above. Rather, more practically, artists have wanted to apply set-consciousness *analogically* as a way of disinvesting 'humanist-expressivism' from the core site of what they do and think, in order to establish new image-text relations and research conditions for art: and, therefore, these relations and conditions may or may not have an explicit relationship to the axioms of mathematical science.[4] Post-Duchampian artists, then, have not necessarily talked of sets at all (or set theory and its pure mathematical objects for that matter), but rather of such cognates as systematic frameworks and predeterminate modes of organization, cognitive templates or sequences, that replace the 'expressive hand' with the technicities and abstractions of sorting, counting, tabulating, archiving and indexing. As such, whichever way we want to look at this shift, since the extensive revival of modes of technical *Gleichgültigkeit* in 1960s art (derived from Duchamp, Constructivism and the Werkbund-Bauhaus), set-consciousness as a branch of artistic praxis has moved out from the desubjectivized margins of avant-garde practice to the centre of what artists want from a new relationship to extra-artistic research and scientific 'systematicity'. In the 1980s this has overwhelmingly transformed the Western metropolitan artist and his or her terms and conditions of labour, creating a new scenic order of production and expanded range of artistic identities: the artist as

collector, collator, taxonomist, gleaner, scavenger, classifier, genealogist. These identities are of course, in their variety and extra-artistic marginality, constitutive of the early avant-garde's assimilation of the detritus of commodity production into the artwork (codified in Benjamin's writing on Dada and Surrealism).[5] But today, these analogic scientific identities have a range and scope that are quite unlike their forbears. That is, they represent a massive epistemological shift, to a *post-subject artistic subject*, in which *Gleichgültigkeit* frames various modes of artistic desubjectivization and technical externalization on an unprecedented scale. The artist subordinates himself or herself to the abstract determinates of a system, framework, procedure, particulars of an environment, by way of the general refusal of artistic production and experience as the outcome of a singular (repeated) encounter with a medium or form. The outcome is a post-Spinozan, mathematized artist, 'free' of the passions and first-person exaltation, so to speak. This is what we might call an iterative artistic subject or the 'subject of the count', whose internalization of *Gleichgültigkeit* is performed through an endless and dispersed process of collecting and sorting of extant things in the world, or cognately who simply repeats a given device or trope as a 'conceptual readymade'. In this sense, 'artisticness' is identifiable with the submission of the act of signification/conceptualization to this endless process of archeological recovery or iteration.

In these terms, 'artisticness' takes on an objective inexorability, in which the analogic scientific identities of collector, collator gleaner, taxonomist, etc. produce a 'set consciousness', or its cognate 'group thinking', as a heuristic method or device. However, this isn't quite the fantasy of the artist as automata, as in early Lazslo Moholy-Nagy, as if this collative process is external to 'decision', 'intention', 'expression'. All the artists who have made these analogical scientific identities their own since the late 1960s – On Kawara (repeated painterly sign), Marcel

Broodthaers (resignified readymades), Carl Andre (repetition of prefabricated uniform elements), Dan Graham (archival photo-collation), Hanne Darboven (scripto-repetition), Hans Haacke (archival photo-collation), Bernd and Hilla Becher (photo-archaeology), Mary Kelly (sequenced domestic readymades), Tony Cragg (collated detritus), Sherrie Levine (photo-repetition) – have shaped the de-subjectifying force of *Gleichgültigkeit* to their own symbolic interests, and, crucially, to the wider *affective* connections between sorting, counting, collating and iteration to the production of subjectivity and the commodity form. Subjectivity and 'subjection to the count' become one. Indeed, the 'mathematization' of the artist as the 'subject of the count', here, can be seen precisely as a way of linking the techniques of repetition to the production of the 'universal subject of the count': the capitalist subject, the subject subjected to clock time and the value form. As a result *Gleichgültigkeit* is enacted from two interrelated perspectives simultaneously: the subjection to the count is the giving of form to reified subjectivity and the technical and social division of labour, and, inversely, a means of technical resistance to the humanist-expressive aesthetic subject that, conventionally, has filled the void left by these forces of reification. Thus, the post-subject artistic subject straddles two subjective orders: on the one hand, the subject's subjection to deathly repetition as repetition, and on the other, the subject's willingness to open itself up to the contingent, to chance, and new cartographies of knowledge provided by the archive and taxonomy. In this sense the 'subject of the count' allows us to draw out a very different perspective from the current development of these analogic-scientific identities than the one Rosalind Krauss made cogent in her discussion of the rise of the grid in 1960s art. In her 1979 essay Krauss talks about the emergence of the grid in the 1960s as a 'compromise' resolution to the 'scientistic' or de-subjectifying turn, insofar as it both masks and reveals this impulse:

The grid's mythic power is that it makes us able to think we are dealing with materialism (or sometimes science, or logic) while at the same time it provides us with a release into belief (or illusion or fiction). The work of Reinhardt or Agnes Martin would be instances of this power... [As such the grid] allows a contradiction between the values of science and those of spiritualism to maintain themselves within the consciousness of modernism, or rather its unconscious, as something repressed.[6]

Today, however, with the expansion of these analogic-scientistic identities, the tension between scientific template as evidence of the artist's renewed technicity and the aesthetic humanization of this technicity as transcendentalizing impulse – as an escape from the full objective implications of technicity – is exhausted. This is because *Gleichgültigkeit* is now the formal expression of the technicity of artistic labour under the mass, industrialized base of cultural production. Art's technicity is the technicity of the culture as a whole (even if it seeks to find other uses for this technicity). What residual spiritual affects prevail under this regime are therefore, incidental to the post-subject artistic subject's subordination of art-making to the realm of de-subjectivized socialized technique. In these terms, the rise in the 1980s of all kinds of artistic practices that reflect on these conditions represent the working out of the technical transformation of the artist's labour and identity on an expanded scale, one that can be said to match these conditions. And this expansion is nowhere more evident than in the work of James Fendel, whose own adaptation and extension of the analogical-scientific identity of collector, gleaner, archivist, is almost Wagnerian in scope and ambition. In this regard his work is both a grandiose symptom of the analogic-scientistic turn and the 'subject of the count', and a fitting extension of its implications under the post-industrial downturn of the Western economies.

Since 1986 Fendel has lived in the upstate New York town of Newburgh (60 miles from New York), which, like other parts of the old industrial Eastern seaboard down to Baltimore, has undergone a vast and devastating de-industrialization. Once a thriving thru-port for New York in the late nineteenth century and early twentieth century, and a centre of the textile and furniture industry and bottling trade, it is now a shrunken community of deskilled workers and people on welfare. Indeed, it has perhaps suffered worse than most cities and towns down the Eastern seaboard; across the town and the surrounding environs (the Poughkeepsie–Newburgh–Middletown metropolitan area) there have been numerous business and property foreclosures, creating an abject landscape of neglect. In 1985 Fendel was able to buy at a knockdown price a large, four-story warehouse in the North West of the town once attached to a Victorian bottling plant, and to create a live-work place for his activities. The purchase has been crucial because without it the work wouldn't have been feasible. Since his arrival he and his assistant Christian Flaherty have travelled across the district in a beat-up Chevrolet collecting and scrounging a vast array of disused, discarded and remaindered machine parts, metal scrap, old tools, glass, plastic products and other industrial detritus, from junkyards, salvage yards and landfills, that they then would process and store in the warehouse. The amount of material collected on a weekly basis in their first year was staggeringly large, and they had to cut back on their collecting rounds. Yet, if the amount of processed material and objects after the first year diminished, it never ever stopped; rather, the collecting became more refined. As the categories and taxonomies and sets expanded, Fendel and Flaherty sought to increase the number of similar objects within a given typological range within each category or set. This meant sorties out into the local junkyards and salvage yards, local streets and abandoned buildings, to look for particular parts and objects. The initial sorting process though

was simple: nothing unduly big – for example, white goods and other domestic appliances or whole machines, which they had collected at first – was to be selected and sorted. Only smaller industrially produced objects, such as toasters or kettles, or parts of objects, including gearboxes, transmission belts, car lights, transmitters and other 'electronic remains', were to be selected, along with an extensive range of small machines parts, as well as nuts, bolts and small panels and plates, long separated from their host machines in the textile industry and the bottling trade. These latter smaller parts and objects, in fact, constituted the majority of the labour of sorting, partly because there was more of this kind of material, but also because more attention was given over to the inspection and identification of each piece, and to deciding which set it might fit into.

Sorting began with the dumping and the building up of large heaps of all reclaimed materials on the fourth floor which became, in the words of Fendel, an 'industrial clearance zone'. Getting the material up to the fourth floor had been impossible at first, and it had languished in the yard adjacent to the warehouse until Fendel and Flaherty had one of the huge goods elevators repaired; from then on the material was run smoothly up to the top floor, and then once selected was taken down to be arranged and displayed in sets on the two floors below. Most of their time though was spent on the top floor, standing or crouching next to piles of materials that in some instances towered above them, and that they labouriously, and sometimes precariously, sorted through. As part of this process of selection Fendel and Flaherty would play a *misère* version of the Chinese game of nim.[7] Each would take an object or objects from their main pile and sort them into other piles (rough sets to be re-sorted later on), in which the person who was left with the last object in his pile after removing all his objects from his main pile was the winner. This isn't as effete and affected as it sounds. *Nimming* (Old German for taking or pilfering) on large scale, and

the life of the *nimmer* – as a recalcitrant and rebarbative version of the post-expressivist artist – were crucial to the ambitions and tenor of the work and its sense of locale: the fact that the work was a huge and unwieldy act of long-term appropriation across a large geographical area, in which the collecting and sorting of materials from the surrounding environment completely dominated the lives of both men. It was not just an archival project of academic or incidental research value; for three years, searching, gleaning, sorting and set-making were indivisible. As such, to find ways of making the sorting bearable was a task of paramount importance. Fendel even called his newsletter – started in order to document all the pick-ups, hitches and other vicissitudes of the project – *The Nimmer* (1986–89). Published every two months on four sides of two sheets of A4, with a quote from Horace under the masthead – '*Est modus in rebus*' ('There is a measure in things') – and occasional photos and maps, he would take it into New York and leave it around galleries and art venues.[8] In the New York art world of David Salle and Robert Longo, however, nobody wanted to hear about an obsessive collector of industrial detritus from out of town. And so Fendel and his newsletter were on a hiding to nothing; roundly ignored. Yet between 1986 and 1989 he persisted with the publication, producing a continuous update on his activities, and as such a vivid documentary and critical account of things selected, collected and arranged, and junkyards, salvage yards, abandoned buildings and landfills visited, and of the surrounding landscape. Here is a typical entry:

11 October 1988
Al Turi Landfill, 2690 Route, Goshen, NY.
Even though it was a breezy morning, the stench was enormous; greeted by one of the dump-guys Mike, who allowed us to drive the Chevy over to the South East side (20 bucks) where he said there was a whole bunch of plastic and

metal stuff. Gloves and masks and plastic overalls on we worked for three hours straight, picking up a reasonable array of plastic containers, garage tools, and machine parts. It is important to keep moving your feet, for the surrounding, sogginess, and soft contours of the landfill, suck you in, and then it's easy to fall over; and that's the last thing you want; skimming goop off your overalls. The hardest bit is seeing something interesting far away, collecting it and returning to the pick-up in one journey; it's exhausting on the legs. This is why landfills may throw up gems, but you certainly work to extract them. Mike, of course, thinks we've got a scam going; and that we're extracting minute amounts of copper from all the electrical goods we take away; he doesn't even hear when we say we're artists. It doesn't compute; it's like we've said we're flower arrangers. Al Turi is one of our best resources though; maybe it's the houses nearby off the Interstate, or maybe Mike is deliberately planting stuff, so he can pick up his 20 bucks a pop, but we always find good stuff; Christian found three 1920s mangles, so we decided to start a mangle category; then we saw mangles everywhere; selecting invites seeing.[9]

In some issues, though, he'd outline a few working 'nimmer axioms' and 'nimmer aphorisms', and reflect on their viability in a kind of 'post-industrial' and post-conceptual version of the 'subject of the count'. For example:

Finding and sorting is the matrix of the artistic act; the 'set' is the form...

Collecting is not an art of memory, but an archaeology of endless crisis...

If art has to find ways of inhabiting the world, the artist has to find ways of inhabiting what is homeless and empty...

The nimmer is not an appropriationist; he is a master of

numbers...

Counting is not a positivism, it is a philosophy of action...

In these terms, whatever daily vicissitudes Fendel and Flaherty faced, the importance of the 'count' never wavered; indeed, everything that was collected, down to old washers and screws, was listed in two huge leather-bound ledgers that Fendel had to lay flat out on the floor to write in. Beside each item he wrote a short description, the date and location found, and, if possible, the date of production. (Flaherty would spend some of his time down at Newburgh library, trawling through old trade publications and manufacturers manuals, trying to trace the origins of items, though with little success; in the end dates were usually guessed at.) If all this appears like the efforts of industrial archaeologists, however, this is not something that Fendel was happy with, and he even actively discouraged it. In *The Nimmer* he repeatedly stressed that they were not building "an industrial museum"; "we are not curators."[10] Yet, the systematicity of what they were doing nevertheless pointed in that direction, and as such, this was the inescapable formal and epistemological problem they had to address as the mounds got taller and the ledger filled up with technical information: what predicates were they to pick out as worthy of the 'count'? What characteristics and typological identities should they select in order to structure their sorting? Should they work just with 'counting numbers' (quantities) or also at some point with 'ordinal numbers' (qualities; first, second, third)? Should cardinality (correspondence across sets) play a part in their decisions? Firstly, though, they had to decide what they *didn't* want to do, that is, follow an adventitious and arbitrary, or aestheticizing and quirky path, in which the sets were determined by completely heterodox characteristics: 'small brown things'; 'things with verdigree spots'; 'things with bits missing'; 'things with the names of manufacturers beginning with B and G'; 'things that you could sit on';

'things that were discolored'; 'things that were made in circa 1957'; 'things that looked like other things'; 'things that you could put in a match box'. Such sets may have deflected the reception of the material from the more obvious and mundane characteristics of museum display and taxonomies, yet, nevertheless, the material was, all things considered, an industrial archive, and had to be respected as such; the final presentation of the 'sets' therefore had to be bound to the reality of this origin, in order to avoid the taint of aestheticization. So, the problem of the 'set' for Fendel and Flaherty was the problem of facing two ways simultaneously: of respecting the function and genealogy of the objects and the materials – of the fact that their accumulated material was a historical corpus, of depth and extensity – yet drawing out qualities and relations that bypassed the customary industrial-archaeological categories. One part-solution was their occasional reliance on 'semigroups'. These are less restrictive 'sets' that base possible membership criteria of a set on various associative aspects of elements, following Russell's Fregean distinction between the extensional (combinatory), and the intensional (predicative).[11] So, for example, a set might consist of toasters and skillets. But these relations were invariably so banal that Fendel and Flaherty eventually dropped the semigroup as a singular way of ordering a set, and only introduced it as subset within a given set, as a kind of 'internal motif'. And, in turn, some of these motifs would be cross-referenced (given cardinal status) through their introduction in other sets. In this way subsets and semigroups were housed inside the sets, just as some sets might find an echo in the subsets of other sets. In the end, therefore, to avoid aestheticizing and adventitious categorizations, Fendel and Flaherty used the logical 'intrigues' and complexities of the set-subset-semigroup relation as a way of opening up the pedantic taxonomies of the industrial archive; the primary qualities and functions of objects were respected categorially, but at the same time they were subject to internal

and external destablizations and declensions. "We realized two years into the project", said Fendel,

> that we shared a common respect for industrial archeology with the Bechers, and as such were involved in a similar project, but at the same time, we didn't want to have anything to do with the mournful rehearsal of fixed typologies. Laying out rows and rows of 1950s hammers in a beautiful square immediately produces a quality of 'forlorn-hammerness' that fixes all the wonderful little design differences and inflexions into a gestalt image of 'lost artisanal' splendor. I don't want to damn the Bechers by association here, but there is something creepy and Heideggerian about this kind of approach; a feeding off of the nostalgia of the industrial archive for easy historical affect; a delectation of absent 'things to hand'.[12]

Thus the declensive moves of the subset and semigroup, and semigroup in the subset, were a way of breaking up these effects, and rerouting taxonomic and categorical understanding through multiple pathways and across uncommon and 'unthought' relations.

In these terms, once they had decided to stop collecting from the yards, landfills and dumps in mid-1989, they spent many months sorting and re-sorting the objects and materials into sets that they felt were worthy of this formal ambition. In this respect they began from a number of primary sets – 'bottle production', 'textile production', 'auto consumption', 'household consumption' – that provided a clear production/consumption axis, with the greater visibility across the majority of sets devoted to items of consumption. Hence function/use-value/site of production/site of consumption became the crucial taxonomies through which the operations of the subset, and the ordinality and cardinality of the 'count', were organized. So, for instance, in one ambitious set produced in 1988, pre-1950s medicine glass

bottles from Newburgh salvage yards were presented in rows, with 1970s generic plastic drugs bottles (from across the USA) found in local landfills, alongside brightly coloured plastic toys based on children's TV characters from the 1980s found in local dumps and on the street. Inserted in these rows, every six rows, was a 4 x 4 square 'fill-in' of components and circuit boards and glass valves from domestic appliances from the 1960s–1980s; each 'fill-in' being staggered diagonally across each of the six rows. The effect was a stuttering intersection of periods, use-values (and their type-forms) and materials. Consequently, this relational complexity places their commitment to the 'subject of the count' in a very different position to that of many other archival-appropriationist practices of the moment with similar 'sociological' ambitions.

For Fendel and Flaherty, de-subjectivization and technical *Gleichgültigkeit* are not a means of thinning out artistic intention to the point of conceptual inertia, and, as such, allowing the sheer extensity of what they do as archivists and taxonomists to stand in a flat, ventriloquized and petrified way for reified subjectivity and the 'post-industrial': the 'death of modernity',[13] the 'end of progress', the 'end of the avant-garde', the 'death of the industrial worker'.[14] Rather, they provide an opportunity to orchestrate new relations between historical consciousness and the commodity on the basis of a sustained engagement with dead labour. One might say, then, that this is the great insight of Duchamp's readymade and the philosophical outcome of the technical expansion of *Gleichgültigkeit* in art: in the act of sorting, renaming and recontextualizing, dead labour is *brought to life*. In Fendel and Flaherty, however, this process of resuscitation reaches another magnitude altogether than that customarily identified with the history of the artistic readymade: the vast intellectual labour of set-production here – of the constant shifting and mutating orders of membership-identities and relations – becomes analogous to a process of living labour itself.

Hence, what started out as a simple exercise in *re*-cognition for Fendel and Flaherty, and a standard melancholic immersion in the vast landscape of the 'post-industrial' – in the spirit of most current appropriationist art – becomes an endlessly transformative and coordinated process of *re*-production. That is, the membership criteria of the 'count' become a source of productivity – *the symbolic and genealogical work of identification and dis-identification*. Predication and combination are intertwined. And this is where an interesting confrontation between artistic labour and productive labour arises, but also where certain problems begin.

Industrial labour-power on a world scale is still the primary source of value for capitalism, even if the heavy industrial forms of value extraction are increasingly 'invisible' in the West. Indeed, the very disappearance of these forms from the landscape, and replacement with other forms of extraction – for instance the disappearance of textile production from Newburgh to other parts of the world – actually tells us this. Yet, if the disappearance of industrial labour is a 'post-industrial' myth on a global basis, nevertheless, the identities of class belonging and workers' attachment to the traditions and symbols are real enough; workers' class identity, particularly in the West, has become largely formal, as a result of the (relative) contraction of industrial labour. As André Gorz has argued, echoing Henri Lefebvre and the Situationists from the 1950s, and Jacques Rancière in the early 1980s, "class [comes] to be lived as a contingent and meaningless fact."[15] Indeed, the "class itself has entered a crisis"[16] in precisely the way Marx predicted in the 1850s. In seeking its own emancipation as a class for itself, the proletariat is confronted with the necessary and unfolding destruction of its own identity as the measure and dynamic of this emancipation; proletarian identity and dis-identity become one. As Gorz, puts it: "It is no longer a question of winning power, but of winning the power no longer to function as a worker."[17] Hence the intense

melancholy attached to the display of dead labour in the current period (that Fendel and Flaherty are so keen to de-aestheticize): the accumulation process continues on a vast and destructive global scale, yet workers' symbolic place in this process is denuded and disaggregated. In these terms the accumulation of the industrial readymade and pursuit of *Gleichgültigkeit* is, in Fendel and Flaherty's hands, essentially an artistic philosophy of (subjective) *remnants*, or, in a slightly different register, a systematic visualization of the *double absence* of labour power. The absences operate, firstly, in terms of the 'hidden' character of the extraction of surplus value, and, secondly, in terms of the symbolic and cultural disappearance of collective labour power itself. One can see, therefore, what is at stake politically – and therefore what is contentious – about Fendel and Flaherty's 'count' as a creative source of *re*-production.

The 'count', in its substitution of artistic labour for productive labour, revives the analogical technical identity of the artist-as-worker on a hubristic scale, in which the artist becomes the voracious and compulsive archivist of the forgotten and covered-over traces of productive labour. Accordingly, the labour of the artist – the labour of the artist as 'the subject of the count' – steps into the symbolically deracinated place of labour-power to do the (analogical) work of labour-identification. The artist, in other words, returns the labour of the worker to symbolic prominence, in an act of identity displacement. There is no doubting the archaeological and critical significance of this move, certainly as against those modes of appropriation that reify the disap-pearance of industrial labour as such, or those that favour, in academic style, the inert and museal presentation of past labour practices. The artist-as-technician steps into the space of dead labour in an act of creative solidarity with both, labour and the critical horizons of the historic avant-garde. But on this scale the repetitive-compulsive character of this labour of reclamation produces a profound 'burden of the count', a never-ending

substitution of the artist for the worker, in which the artist in a God-like move seeks to reclaim, through the 'light of mass resurrection', all dead labour, all the 'dead souls' of labours past.

One might ask then: is *Gleichgültigkeit* susceptible to the classic masculine ethnographic trap? That is, is the agency of the artist as the 'subject of the count', the repetitive-compulsive activity of the collector (the 'data cruncher') and the masochistic projection of masculine non-relationality into the outer depths of oblivion? There are no women doing this kind of work, on this scale, and one would assume for good reason. Eva Hesse, Mary Kelly, Hanne Darboven and Sherrie Levine have all subjected themselves to the 'count' – as a 'post-gendered', technical 'retraining' of women's art – but not on a scale where the 'count' opens itself up to the infinite and the void, and the set-theoretic mapping of the whole world. Is there some special symmetry, some isomorphic connection, then, between male (deflected) authorship, cognition and the count? What is being actually played out here: simply the crisis of the identity of the productive labourer (under the global rise of the organic composition of capital) or the enduring spectre of the male artist as an 'empty set'? Clearly, Fendel and Flaherty's Newburgh project presently assumes a kind of leadership role in its application of the techniques of *Gleichgültigkeit*, given the work's extensive capturing and expansion of many of the 'non-expressive' strategies of the avant-garde and neo-avant-garde. In these terms the count is certainly indivisible from an (undeclared) heroism of the (male) artist as the 'maker of worlds' *sui generis*.

But, despite the repetitive-compulsive form, despite the vast inflation of the analogic-scientific character of the set-forming artistic subject, despite the hubris, the Newburgh project is not an imposture of the count on the 'free particulars' of the world, nor the application of an order on things where none is required. This is the reactionary side of the gendered critique of the count. For, the 'count', on whatever level of magnitude it is pursued, is

something profoundly egalitarian, insofar as the 'count' is always marked by inclusion and openness to contingency, even if the will to include is always determined by the desire to exclude, as the necessary corollary of the latter. That is, to 'count' is to *pass on* the count as a judgement on the things 'counted' – as that which is worthy of the given count – to another, known or unknown, who in turn may form an inclusive/exclusive count based on their own judgement (extension or contraction) of the inherited count, and other counts. Thus the localized character of the count is always a claim on what has *not been* counted (on the exclusions of other counts), or counted poorly or ineffectually in other counts. This is why the passage of one count into another count is also expressly a mnemonic procedure. The judgement inherent to the count of what has not been counted, or counted poorly, is also a claim on what *should be* included or retained in any other count. Hence if, in the case of those who have the power to control what counts as a count, the count is handed on without the possibility of a 're-count', the crucial function of the count of the uncounted is to pass on what has been previously uncounted as the memory of the uncounted. And this process is never secure; the new count can equally well forget what was counted as uncounted. In these terms the count is always involved, contrawise, in the difficult work of *anamnesis*, the repetitive labour of recollection. As Fendel says:

Counting is what we do to register where we are and where we've been and where we might be going and with whom, and consequently the making of sets is the contingent and restless form of this counting. In fact we count all the time, in order to 'counter' the counting of others; there is nothing strange or obtuse about this. Thus in a simplistic fashion, for example, it is important to list all the worthwhile things that you've read, seen and admire, and pass this 'count' onto others; your 'count' may not persuade others, and therefore,

the counts of others may not contain many, or any, of the things of your count, yet, where things *are* counted together as one (where cardinality emerges) new forms of counting the uncounted emerge as well.[18]

Consequently, there is a wider ethics of the count here; in counting the uncounted it is obviously important to count what is missing, but, more precisely, it is also important to count the missing in that which has been counted *as not missing*: the buried bodies, the executions performed, the prisoners incarcerated, the jobs destroyed, the artworks left unconsidered, the books left unread, the strikes squashed, the animals extinguished, the monuments and communities of the vanquished destroyed. Capital counts time, profit levels and the unemployed as a counting-out; the artist, the philosopher and political activist 'count out' as a way of *counting in*. As such Fendel and Flaherty's count is neither the humanization of abstraction, nor a positivistic imposition of order. It is an act of resettlement.

On October 19th 1989, *The Newburgh Project* opened to the public for the first time. The numbers were initially small, but within two weeks the word got around, and the numbers got larger, with people queuing into the yard. Floors three, two, and at the last moment one had been given over to the 'sets'; with enough room allotted between 'sets' in order to walk around them. Twelve 'sets' or two 'perfect sets' of six were laid out on either side of each floor, seventy-two 'sets' of 10 x 10 objects in all (exactly 7200 items). In addition each 'set' had its own notation sheet, listing, type, origin and location of each object. The first floor was given over predominantly to 'bottle production', the second floor to 'textile production', and the third floor to 'auto consumption' and 'household consumption'. But these were not strict divisions; some machine parts from 'bottle production', 'textile production' and 'auto-consumption' found their disruptive way into two 'sets' on the third floor and into

'household consumption', on the grounds that some parts from the machinery of 'bottle production', 'textile production' and 'auto-consumption' shared certain typological characteristics with various domestic appliances. Similarly, plastic household objects found their way into some sets that contained plastic parts from automobiles. On January 5th 1990, the installation officially closed. However, such was the level of public enthusiasm that Fendel and Flaherty extended the exhibition for two extra weeks, while they finalized the sale of the building. On January 19th, the penultimate day of the extension, Fendel and Flaherty posted up a notice around Newburgh, which stated that on the following day, everyone who visited could take away one object, with its paper certification. By 7pm on the 20th over 2000 objects had been taken. On the 25th the building was handed over to the new owners, along with the remaining 5000 or more objects.

Notes

1 Bernard Belzano, *Paradoxien des Unendlichen* [1851], (Leipzig: Verlag Von Felix Meiner, 1920). "*Einen Inbegriff, den wir einem solchen Begriffe unterstellen, beidem die Anordnung seiner Teile gleichgültig ist (an dem sich also nichts für uns Wesentliches ändert, wenn sich bloss diese ändert)*": p.4.

2 Kurt Gödel, *Collected Works*, Vol 11, Publications 1938–1974, Solomon Feferman, John Dawson and Stephen Kleene, eds, (Oxford: Oxford University Press, 1990).

3 Empty with an upper case 'E' is my designation; empty with a lower case 'e' in standard set theory defines a set with no elements in it. However, we should be clear here: the 'empty set' has not dissolved and become a non-set. That is, it may be *absent* of all elements, but it is still possesses one element: its own 'empty-set-ness.'

4 Thus some early avant-garde artists have taken an interest in

mathematical knowledge and axioms, such as Malevich, Mondrian, van Doesburg and Duchamp, and applied them as 'creative strategies'. But many have not, invariably presenting their interest in mathematical science as an intuitive, aesthetic move, as Man Ray did in his photographs of the non-Euclidian 'pseudo-sphere' objects he discovered at the Institute Poincaré in 1934, which then became the basis for his illustrative painting of these forms, *Antony and Cleopatra* (1934), or from the most generic of perspectives, such as those artists interested in 'simultaneity' and 'multidimensionality'.

5 What Peter Bürger has called the 'inorganic'. See *Theory of the Avant-Garde* (Minneapolis: University of Minnesota Press, 1984). For Benjamin, see *One Way Street and Other Writings*, trans. Edward Jephcott and K. Shorter (London: New Left Books, 1979).

6 Rosalind Krauss, 'Grids', *October*, 9, Summer (1979): pp.54–55.

7 For a discussion of the mathematics of nim, see Fred Schuh, *Wonderlijke Problemen; Leerzaam Tijdverdrijf Door Puzzle en Spel* (Zutphen: W.J. Thieme & Cie, 1943), trans. as *The Master Books of Mathematical Recreations*, by F. Göbel, and ed. by T.H. O'Beirne (New York: Dover Publications, 1968).

8 *The Nimmer* methodically documents all their scrounging, deals and pick-ups, and all the strenuous effort involved in sorting, cleaning and selecting the objects and materials.

9 *The Nimmer*, 18 November (1988).

10 *The Nimmer*, 9 (1987). See also, *The Nimmer*, 5 (1986).

11 Bertrand Russell, *Introduction to Mathematical Philosophy* (London: Allen and Unwin, 1920).

12 *The Nimmer*, 21 (1989).

13 Jean-François Lyotard, *La Conditione Postmoderne: rapport sur le savoir* (Paris: Les Editions de Minuit, 1979).

14 André Gorz, *Adieux au prolétariat: Au delà du socialisme* (Paris:

Editions Galilée, 1980).

15 Ibid., p.93.
16 Ibid., p.93.
17 Ibid., p.93.
18 James Fendel, *The Nimmer*, 23 (1989).

Conclusion

Implicative Strategies

It is important not to 'make things up' and call it history; hence, allowing the virtual to enter the space of history is not an excuse for free-form fantasy and idle speculation. Indeed, the writing of historical narratives as 'as-if' stories is a gross impertinence, and, unfortunately much loved by people who think history is merely the realm of competing and multiple fictions. Thus, the preceding artistic narratives and theoretical encounters might be said to be fictive in the conventional sense, but they are certainly not made up – a significant and profound distinction. This is because there is nothing to suggest that the works of the five artists I have produced on the page lack historical veracity, despite the imagined origins of their authorship and the artists' biographies. And, therefore, accordingly, there is nothing to suggest that the work is incapable of producing a range of truth-effects as the outcome of this virtual life. Consequently, these truth-effects are not just the result of producing the work from out of a range of convincing historical and artistic settings, but more crucially, of the 'world-building' possibilities involved in the production of the artwork as an imaginary-act-as-art-idea. Representation as an act of 'world-building' is not something that we should presume only exists in novels or films. On the contrary, it can be employed equally convincingly in the domain of the theoretic-analytic encounter; in producing real-world problems from the theoretical-analytical encounter with a fictively created range of works, theory is able to produce fictively real objects *as* true objects. Hence the use of such oblique strategies has nothing to do with the blurring of fiction and the real, nor any other such feeble half-truth. No blurring is going on here, contrary to all the commonplace assumptions of 'metafiction'. The theoretic-

analytic as virtual encounter with the object, rather, finds its place *in* the real, *as* the real, in the same way that Duchamp's own fictive encounter with the art object and truth – the incidental photograph of a lost object – made no distinction between art's powers of conceptual disclosure and art's real-world transformative effects. *Fountain* had no material existence, had no exhibition record, yet it produced a truth-effect that changed the conditions under which art was thought, made and historicized: its materiality was indistinguishable from its virtuality. This, accordingly, puts a great deal of pressure on the notion that it is only the extant and sensibly visible objects or events that are able to carry the meaning of art. For, works unseen and works 'made-unmade', since Duchamp, have participated in the discursive production of what we now know as the essential post-morphological condition, of art after Duchamp.

But what, one might ask, of the retroactive insertion of an imaginary artwork into a given historical sequence, with all its fixed reference points? It is one thing to enact the virtual-as-material in the present, in order to extend the virtual life of contemporary art; it is another to mess with chronology, canon and place. Indeed, it is; and this is why, whatever fictiveness might be attributed to the work of the artists in *Thoughts on an Index Not Freely Given*, they are certainly not creative anachronisms, or parables of the 'lost moments' beloved of the rewriters of history. Rather, they are the working-through of a range of given historical materials, of horizons of possibility, in order to draw out more fully the conceptual and analytic presumptions and invitations of these horizons. Hence the very tight constructions I put in place: there is nothing that is theoretically implausible, nothing that overstretches what might have been thought and done in the period; no references to 'issues' and 'themes' that stretch credulity, that would make this reconstructive work a mere 'act of the imagination'. And this precisely is what I mean by describing this historical approach as 'implicative'; it works to

extend, confront, adjust and refigure the aporias, dead-ends, omissions, potentials, of a given context, in order to heighten and clarify their ramifications and effects; but, crucially, this is done *with all the benefits of (Hegelian) hindsight*. The implicative is an act of inferential extension, the reconstructive adaptation of the tendencies and possibilities of a given moment.

Thus the issues and concepts drawn out in these four essays were certainly in play in some form during the period, but they did not take *these particular forms*, because these forms are the actual outcome of my encounter with the works I have created. Apophatic entropy as the *deed* of painting; painting as a 'deathly beginning'; the critique of femininity as the critique of neotony; the living-installation and the installation as a 'clearing of the clearing'; the *Vertretung-Darstellung* conflict and *Darstellungsmethode*; technical *Gleichgültigkeit* and the artist as the 'subject of the count': these concepts, then, are the result of the implicative encounter, the result of theoretical work on each work and its historical constructedness. In other words, the art had to be produced on the page for the concepts to emerge and bear fruit.

However, how fecund actually is this? It might be said that I don't push this speculative conceptualization far enough, given the localized fictiveness of the encounter. Why delimit such counter-thinking or alter-thinking to the implicative? Why simply *re*-construct and amplify? But, this is always the cry of those philosophers who put speculation *first*, as if the past has no traction on the present, yet it is precisely the traction of the past and its claims on the present that are at stake here. To know that one can speculate is to win little from historical struggle, not because it is baldly utopian or freely indeterminate, but because it freezes history out of the vicissitudes of practice, as if history is the redundant mass that *falls behind* all conceptualization and its hopeful or glorious future. If speculation is the radical creed, then history is always the dead space from which speculation

departs, and not the space out of which praxis and speculation are born. History is neither a free zone of speculation for the future nor the inert space of revisitation; rather, it is a place from which practice is reflexively actualized and brought to comprehension. And this is why the implicative necessarily functions as the intervallic form of the virtual-material in these fictive-nonfictive engagements. For, it serves to formalize the dis-alignment of the past with history, as the basis of recovering the production of this dis-alignment as practice in any open-ended account of the present. The virtual here, then, is a materialism presented in the guise of an idealist critique of the dead-materialism of a postmetaphysics (or anti-Hegelianism). In other words, the implicative is the axiomatic form of the virtual as the nongivenness of the given. But why focus on the *past* in this way? Why not apply such a strategy to the present? Well, the answer is contained in the question. In producing the implicative out of the past, one also writes the present.

Contemporary culture has eliminated both the concept of the public and the figure of the intellectual. Former public spaces – both physical and cultural – are now either derelict or colonized by advertising. A cretinous anti-intellectualism presides, cheerled by expensively educated hacks in the pay of multinational corporations who reassure their bored readers that there is no need to rouse themselves from their interpassive stupor. The informal censorship internalized and propagated by the cultural workers of late capitalism generates a banal conformity that the propaganda chiefs of Stalinism could only ever have dreamt of imposing. Zer0 Books knows that another kind of discourse – intellectual without being academic, popular without being populist – is not only possible: it is already flourishing, in the regions beyond the striplit malls of so-called mass media and the neurotically bureaucratic halls of the academy. Zer0 is committed to the idea of publishing as a making public of the intellectual. It is convinced that in the unthinking, blandly consensual culture in which we live, critical and engaged theoretical reflection is more important than ever before.